LIVERPOOL

THE POSTCARD COLLECTION

ALAN SPREE

AMBERLEY

First published 2021

Amberley Publishing
The Hill, Stroud, Gloucestershire, GL5 4EP
www.amberley-books.com

Copyright © Alan Spree, 2021

The right of Alan Spree to be identified as the
Author of this work has been asserted in accordance with
the Copyrights, Designs and Patents Act 1988.

ISBN 978 1 3981 0470 9 (print)
ISBN 978 1 3981 0471 6 (ebook)

British Library Cataloguing in Publication Data.
A catalogue record for this book is available from the
British Library.

Origination by Amberley Publishing.
Printed in Great Britain.

INTRODUCTION

I never really gave Liverpool much thought until the start of Merseybeat in the early 1960s. Since then, I have visited the city many times and explored some of its places of interest, including the Beatles Museum, Albert Dock, Pier Head and the William Brown Museum. My granddaughters now live across the Mersey, so I have also used the tunnel on many occasions.

This book is a collection of postcards from the mid-nineteenth century to the 1940s.

A Short History: Up to the 1950s

Liverpool began as a small fishing village, not large enough even to warrant a mention in the Domesday Book of 1086. It appears to have sprung to life when King John granted it a royal charter in 1207. John needed to establish a port in north-west England from which he could quickly dispatch men and supplies across the sea to reinforce his interests in Ireland. As well as a port, a weekly market was also started, which attracted people from all over the area to Liverpool. Even a small castle was built.

In 1235, the building of Liverpool Castle was completed. This stood on the spot where the Queen Victoria Monument now is, on the aptly named Castle Street. The castle was demolished in 1726.

In its early days, Liverpool comprised of just seven streets, which are all still there today: Bank Street (now Water Street), Castle Street, Chapel Street, Dale Street, Juggler Street (now High Street), Moor Street (now Tithebarn Street) and Whiteacre Street (now Old Hall Street).

In 1642, the English Civil War between Royalists and Parliamentarians started. After changing hands a number of times, Liverpool was attacked and the town was eventually sacked by a Royalist army led by Prince Rupert in 1644. Many of the townsfolk were killed in the battle. Liverpool remained in Royalist hands just a matter of weeks, as in the summer of 1644 they were defeated at the Battle of Marston Moor. Following the battle, the Parliamentarians gained control over most of northern England, including Liverpool.

The massive growth and prosperity in the seventeenth century was, in the main, paid for by the infamous triangular trade of sugar, tobacco and slaves between the West Indies, Africa and the Americas. Being strategically placed to exploit such transatlantic trade, Liverpool soon became the fastest-growing city in the world.

In 1715, the first ever commercial wet dock was completed in Liverpool on the River Mersey, which was then known as Thomas Steer's Dock. The dock accommodated up to 100 ships and was originally a tidal basin accessed directly from the river, and by 1737 via Canning Dock.

In 1846 came architectural triumph when the Albert Dock complex was constructed, consisting of a number of wet and dry docks. Liverpool was a hive of cargo trade from all over the world.

In 1830, Liverpool and Manchester became the first cities to have a rail link. The town grew in wealth and a number of major buildings were constructed to reflect this. Among these are St George's Hall, the Congregational and Lime Street station.

By 1851 the population of Liverpool reached more than 300,000, and a large number included Irish immigrants fleeing the potato famine of the 1840s.

Following the American Civil War between 1861 and 1865 Liverpool's dependency on the slave trade declined. Manufacturing industry, however, was booming, particularly in such areas as shipbuilding, rope making, metalworking, sugar refining and machine making.

In the late 1860s many Chinese migrants first arrived in Liverpool as a result of employment of Chinese seamen by the Blue Funnel Shipping Line, creating strong links between the cities Shanghai, Hong Kong and Liverpool, mainly importing silk, cotton and tea. This all added to Liverpool's multinational cultures.

Liverpool's growing wealth was reflected in the many impressive public buildings and structures that appeared throughout the town, including the Philharmonic Hall (built in 1849), the Central Library (1852), St George's Hall (1854), William Brown library (1860), Stanley Hospital (1867) and Walker Art Gallery (1877). Stanley Park opened in 1870 and Sefton Park followed in 1872. Another notable building is Albion House, which was constructed between 1896 and 1898 opposite the Pier Head. It was the home of the White Star Line shipping company and the ill-fated RMS *Titanic*.

Liverpool officially became a city in 1880, by which time its population had increased beyond 600,000.

Following the building of several new docks, Liverpool became Britain's largest port outside of London by the end of the century. The Manchester Ship Canal was completed in 1894.

Around the turn of the twentieth century the city's trams were converted to run on electricity. In 1904, the building of the Anglican cathedral began. In 1913, an international exhibition took place in Edge Lane. By 1916 the three Pier Head buildings, including the Liver Building, were complete. This period marked the pinnacle of Liverpool's economic success.

The formerly independent urban districts of Allerton, Childwall, Little Woolton and Much Woolton were added in 1913, and the parish of Speke was added in 1932.

The Great Depression hit Liverpool badly in the early 1930s, with thousands of people in the city left unemployed. This was combated by large housing projects (largely built by the local council) creating jobs – mostly in the building, plumbing and electrical trades.

The rising popularity of motor cars led to congestion in the city, and in 1934 the city gained its first direct road link with the Wirral Peninsula when the first Mersey Tunnel road was opened. Queensway, as the new tunnel was named, linked Liverpool with Birkenhead at the other side of the Mersey.

In the 1940s Liverpool suffered much damage as a result of the Blitz, with eighty air raids devastating homes and killing over 2,700 inhabitants. Significant rebuilding followed the war,

including the construction of massive housing estates and the Seaforth Dock – the largest dock project in Britain.

In the 1950s the city struggled after a decline in manufacturing at the docks. During those times music became an escape for the people of Liverpool, and in 1960 one of Liverpool's most famous exports was born – the Beatles. The city became the centre of 'Merseybeat', with thanks to the Cavern Club, which opened in 1957.

MAP OF THE AREA COVERED

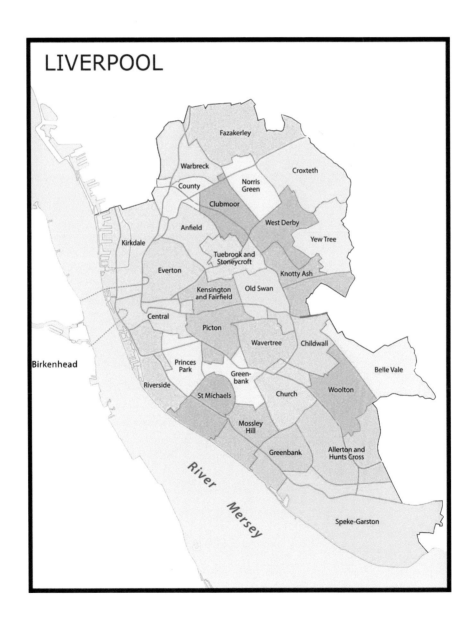

LIVERPOOL

Fazakerley

Warbreck

County

Norris Green

Croxteth

Clubmoor

Anfield

West Derby

Kirkdale

Yew Tree

Tuebrook and Stoneycroft

Everton

Knotty Ash

Kensington and Fairfield

Old Swan

Central

Picton

Wavertree

Childwall

Birkenhead

Princes Park

Belle Vale

Green-bank

Riverside

St Michaels

Church

Woolton

Mossley Hill

Greenbank

Allerton and Hunts Cross

River Mersey

Speke-Garston

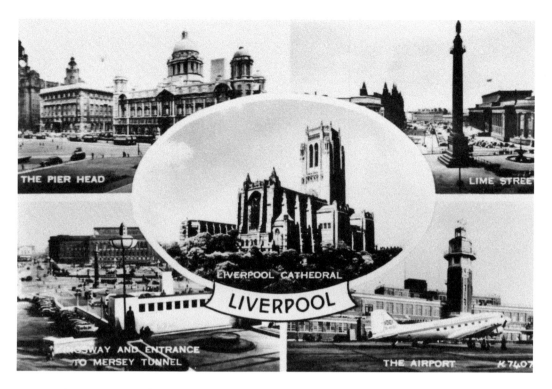

Multi-view Postcards

These multi-view postcards show many of the attractions in Liverpool and include images of the cathedral, Sefton Park, St John's Gardens, the Pier Head, Lime Street, Kingsway, Castle Street and the Queen Victoria Monument, all of which are featured in this book.

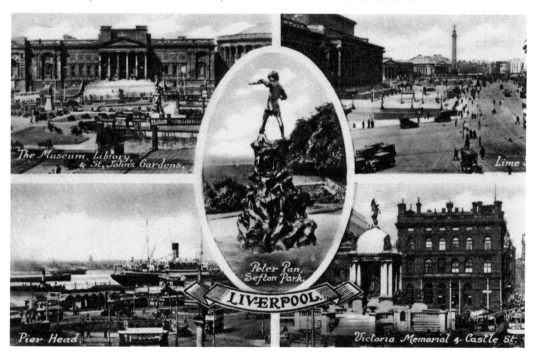

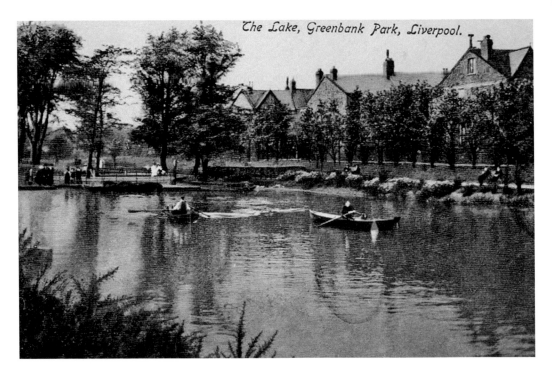

The Lake, Greenbank Park, Liverpool.

Greenbank Park

Greenbank Park is located at the junction of Greenbank Road and Greenbank Lane and is laid out with gardens and a lake. The area was the former home of the Rathbone family, philanthropists through two centuries. The family acquired nearby Greenbank House in 1788 as a holiday house and remained there until 1940.

OLD ENGLISH GARDEN GREENBANK PARK, LIVERPOOL.

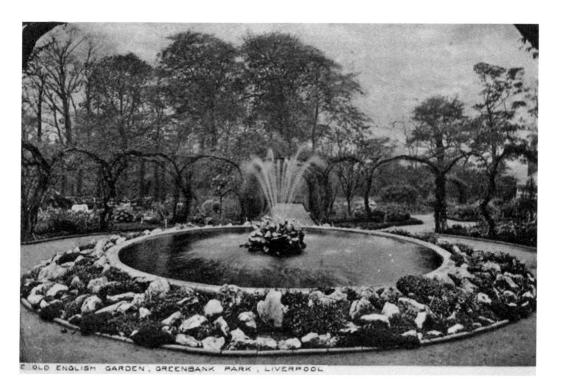

OLD ENGLISH GARDEN, GREENBANK PARK, LIVERPOOL

Greenbank Park

In 1897, Liverpool Corporation entered into an agreement with the Rathbone family to purchase a piece of the land, part of which is now Greenbank Park. The agreement required the Corporation to maintain this land as open space or recreation ground for the general public.

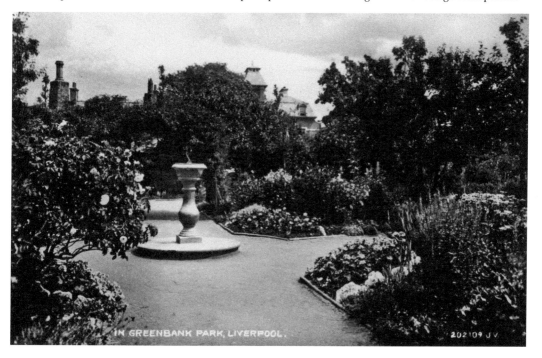

IN GREENBANK PARK, LIVERPOOL. 202109 J.V.

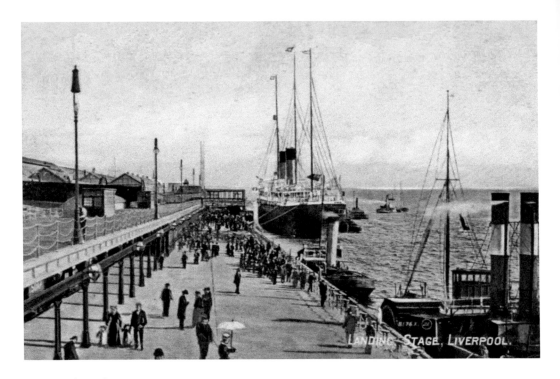

Pier Head Landing Stage

Originally, the Prince's Landing Stage was situated at the Pier Head to serve the transatlantic liner service. There were a number of these stages built during Liverpool's history, the most recent of which opened in the 1890s and was joined to the neighbouring George's Landing Stage, situated to the south.

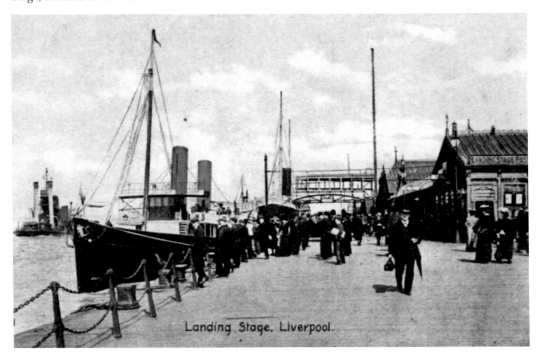

Landing Stage. Liverpool.

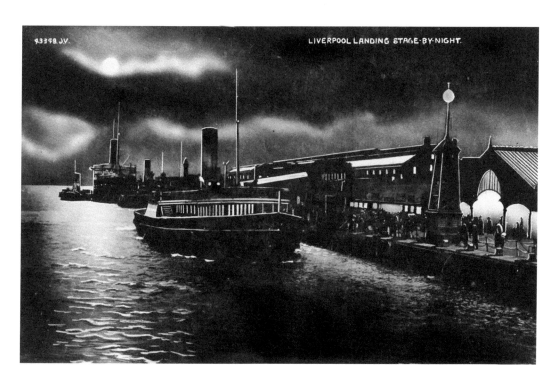

Pier Head Landing Stage

These stylised night-time images show the landing stage located near to the Royal Liver, Cunard and Dock Office buildings, which are shown in the image below and are off to the right of the image above.

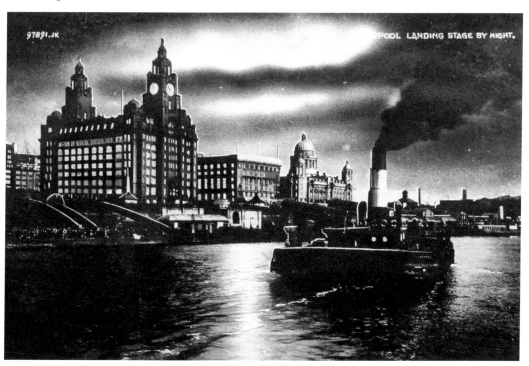

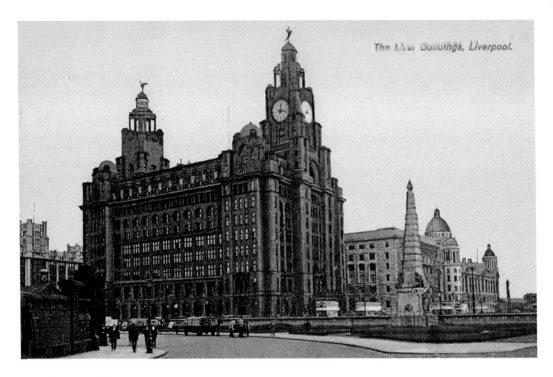

Royal Liver Building

Opened in 1911, the building is the purpose-built home of the Royal Liver Assurance group, which had been set up in the city in 1850 to provide locals with assistance related to losing a wage-earning relative. This was one of the first buildings in the world to be built using reinforced concrete. The Royal Liver Building stands at 322 feet tall to the top of the spires, and 167 feet to the main roof.

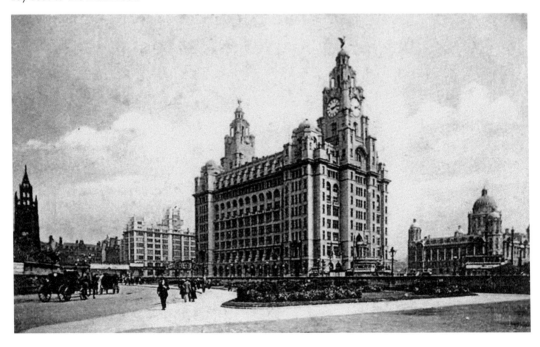

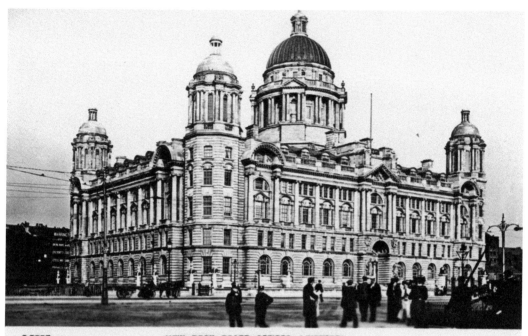

S.2557 NEW DOCK BOARD OFFICES, LIVERPOOL.

Dock Offices

This building is located at the Pier Head along with the neighbouring Royal Liver Building and Cunard Building. It was constructed between 1904 and 1907 with a reinforced-concrete frame that is clad in Portland stone. The building is in the Edwardian baroque style and is noted for the large dome and cupola at the top. The building is 220 feet high.

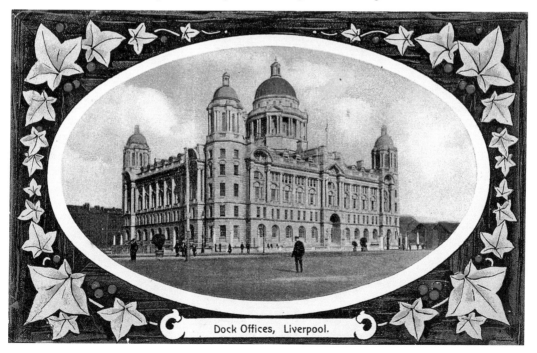

Dock Offices, Liverpool.

13

Mersey Ferries

Benedictine monks ran the first regular ferry from Birkenhead to Liverpool. The monks would row over to the fishing village in Liverpool on market days and offer the service to travellers. The service was granted a royal charter by Edward III in 1330. Edward III also granted the right to the Earl of Chester to run the ferry service from Seacombe to Birkenhead, establishing the Wallasey ferry. These two operations merged, becoming Mersey Ferries in 1968.

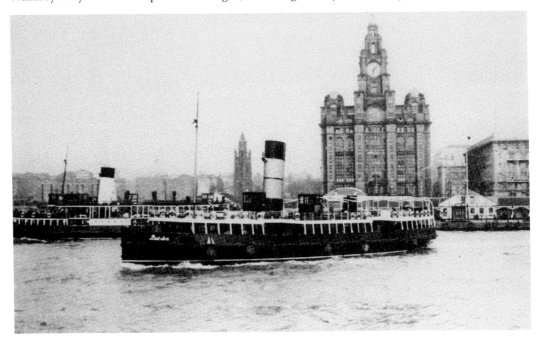

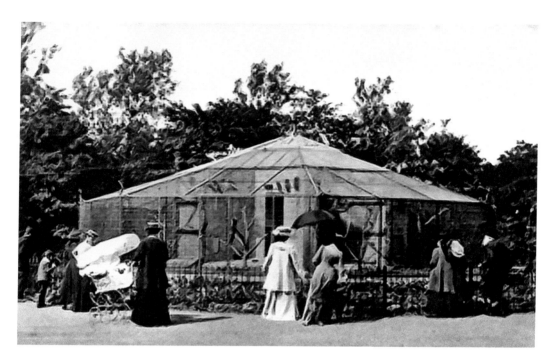

Newsham Park Aviary

Newsham Park is bounded by West Derby Road in the north and the Canada Dock railway line in the east and covers 121 acres. The park was opened in 1868 and is built on land purchased by the Liverpool Corporation from the Molyneux estate. The development of the park was funded by the sale of plots for the construction of housing. Introduced in 1902, the aviary was a late addition to the park, and the birds on show included a collection of brightly coloured parrots. The aviary was taken down in the 1930s.

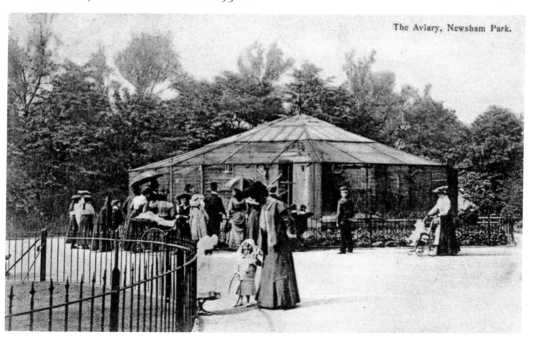

The Aviary, Newsham Park.

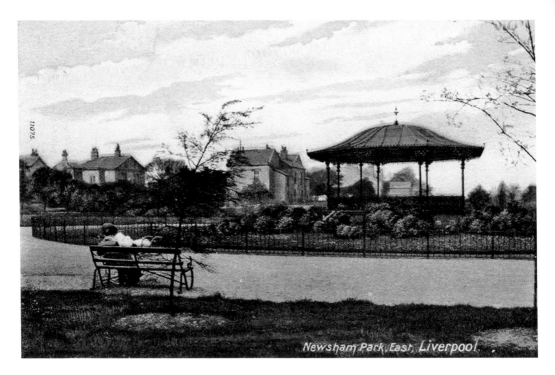

Newsham Park Bandstand
The bandstand is constructed with decorative ironwork pillars supporting an East Asian-inspired roof. It was not included in the original layout of the park by the architect Edward Kemp and was installed thirty years after the park was opened.

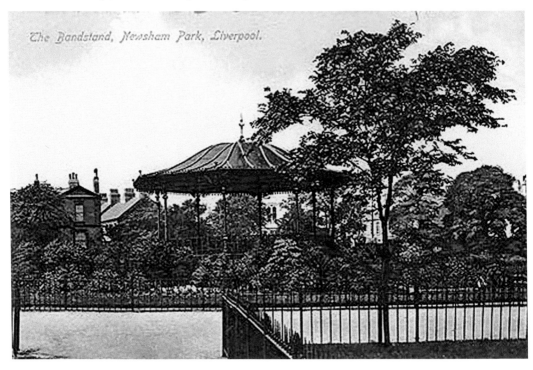

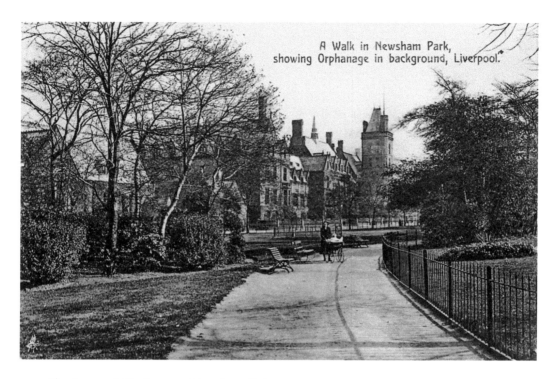

A Walk in Newsham Park, showing Orphanage in background, Liverpool.

The Seamen's Orphanage, Newsham Park

In 1870, permission was granted to erect a substantial orphanage on an unsold piece of land on the eastern edge of the park. This area had proved particularly unpopular with developers due to its close proximity to the railway line. The Seamen's Orphanage was designed by the local architect Sir Alfred Waterhouse. The orphanage was formally opened on 30 September 1874 by the Duke of Edinburgh and was closed on 27 July 1949.

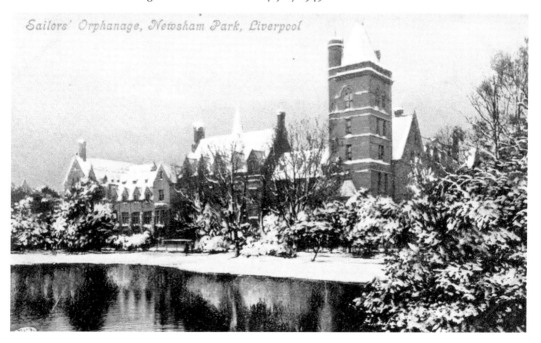

Sailors' Orphanage, Newsham Park, Liverpool

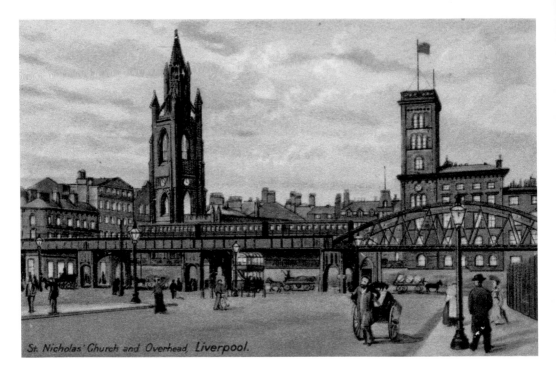

St. Nicholas' Church and Overhead, Liverpool.

Overhead Railway

The Overhead Railway was built in 1893 to ease congestion along Liverpool's docks and originally ran for 5 miles from Alexandra Dock to Herculaneum Dock. The railway was extended at both ends over the years of operation, as far south as Dingle and north to Seaforth & Litherland. The railway closed at the end of 1956.

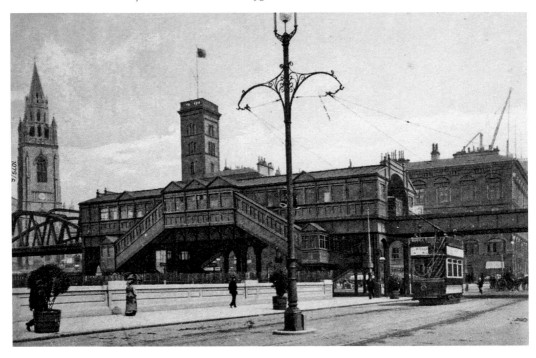

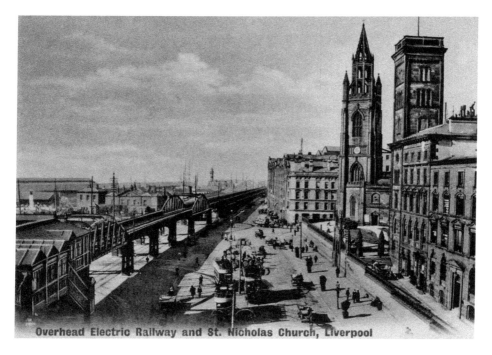

Overhead Electric Railway and St. Nicholas Church, Liverpool

Overhead Railway

The railway had a number of world firsts: it was the first electric elevated railway, the first to use automatic signalling, electric colour light signals and electric multiple units, and was home to one of the first passenger escalators at a railway station. These images also show the Church of Our Lady and St Nicholas on the right.

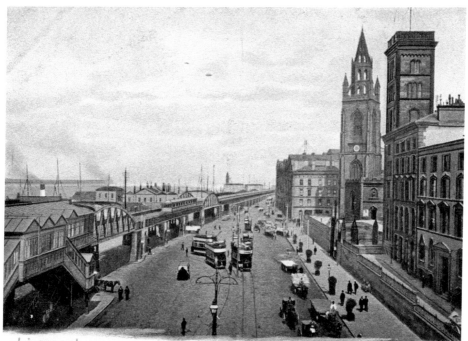

Liverpool. Overhead Railway.

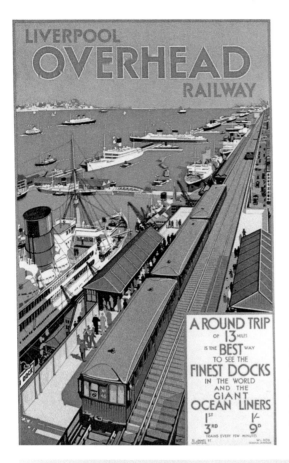

Overhead Railway

The railway was also marketed as a tourist attraction as it provided amazing views of the docks, shipping and transatlantic liners on the River Mersey. These images show two advertisements issued as postcards.

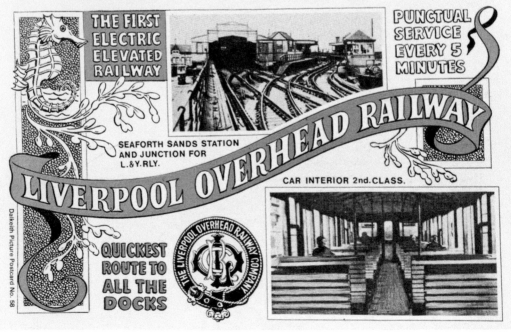

Town Hall

The Town Hall is located in High Street at its junction with Dale Street, Castle Street and Water Street. The original Town Hall was a thatched roof building with the mayor's office above and trading below. The current Town Hall, the third to be built on this site, is one of the oldest buildings in the city centre. The first Town Hall was built in 1515, and the second in 1673. The existing Town Hall was built in 1754, but was then damaged by fire and rebuilt between 1795 and 1820. The statue that crowns Liverpool Town Hall is called Minerva, the Roman goddess of wisdom and protector of cities.

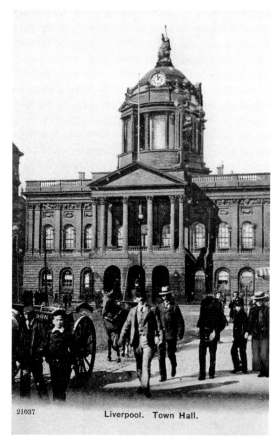

21037 Liverpool. Town Hall.

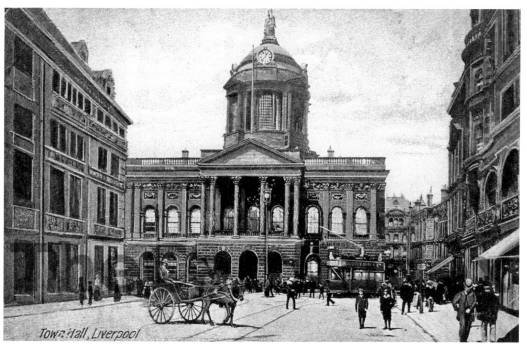

Town Hall, Liverpool

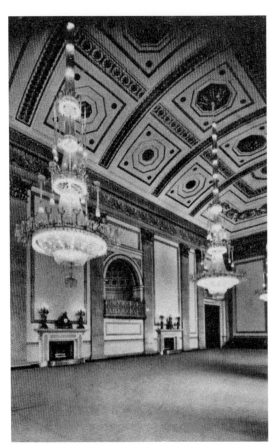

Town Hall

The large or main ballroom shown on the left is 89 feet long and 42 feet wide, with a 40-foot-high ceiling. This room on the first floor contains three of the finest Georgian chandeliers in Europe. Made in Staffordshire in 1820, each chandelier is 28 feet long, contains 20,000 pieces of cut glass crystal and weighs over a ton.

The interior vestibule, or entrance hall, shown below is graced by a Minton tile floor showing the arms of Liverpool. The walls are decorated with murals created in 1909, showing scenes of the city's history from King John creating Liverpool as a free port to the city as a centre of culture, commerce, education and progress.

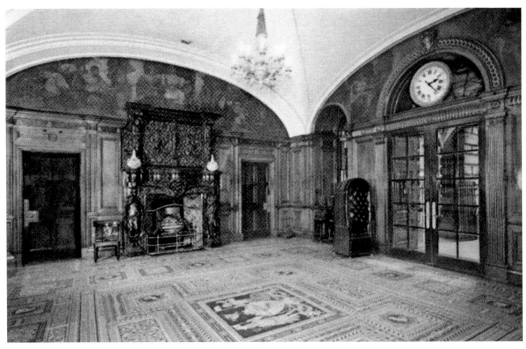

Nelson Monument

Located at the rear of the Town Hall in Castle Street is a large open courtyard called Exchange Flags. The Nelson Monument was commissioned in 1809 and unveiled in 1813. It was designed by Matthew Cotes Wyatt and sculpted by Richard Westmacott. It is a circular stone monument with a bronze sculpture group on top featuring Nelson astride a cannon, Victory above him, a sailor, a mourning Britannia and a skeleton emerging from beneath a draped flag. Around the pedestal are prisoners of war in shackles, interspersed with four panels showing Nelson's victories at St Vincent, the Nile, Copenhagen and Trafalgar.

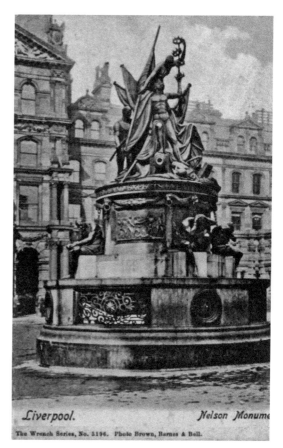

Liverpool. *Nelson Monume*

The Wrench Series, No. 5196. Photo Brown, Barnes & Bell.

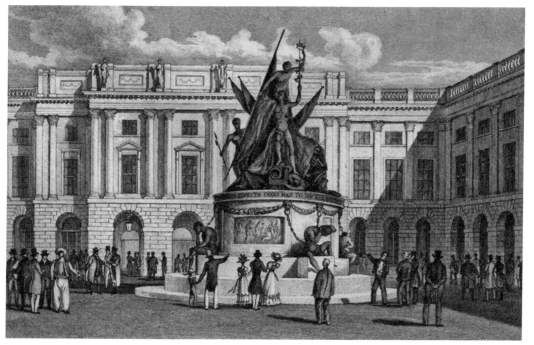

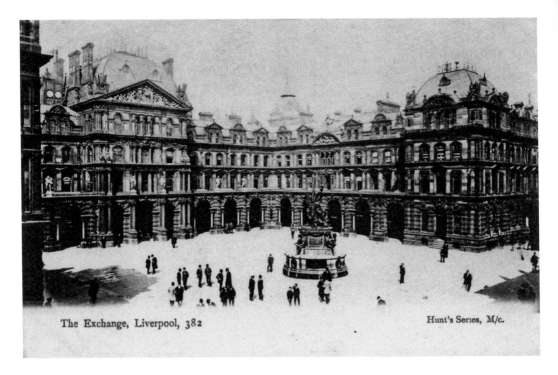

The Exchange, Liverpool, 382 Hunt's Series, M/c.

Cotton Exchange

The business of the Cotton Exchange was originally conducted outdoors on Exchange Flags, behind the Town Hall. The first Cotton Exchange was built in 1808 adjacent to the flags. The second building, in Old Hall Street, shown on the images, was erected in 1905–06 to a design by Matear & Simon. The building was officially opened by the Prince and Princess of Wales on 30 November 1906.

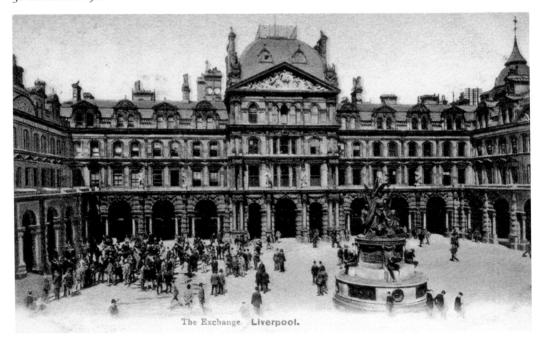

The Exchange. Liverpool.

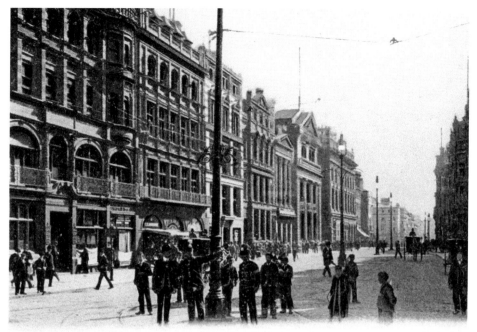

21041 Liverpool. Castle Street.

Castle Street

Castle Street, which is approximately 220 yards long, runs from the Queen Victoria Monument on James Street to the Town Hall. It is named after the castle that used to sit on the site of Derby Square and is one of the original seven ancient streets of Liverpool, appearing on maps from the thirteenth century onwards. The street was the site of medieval fairs and a boundary marker from this period, the Sanctuary Stone, still remains. Castle Street was originally narrow and barely wide enough for two carts to pass through, but like the other streets it too was widened in the eighteenth and nineteenth centuries.

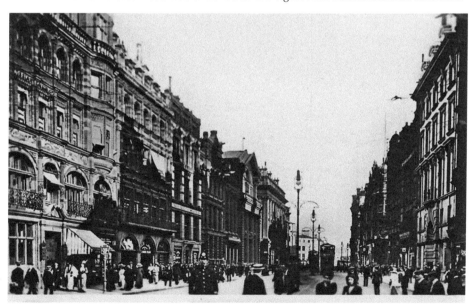

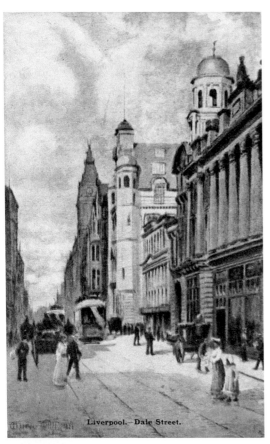

Liverpool.—Dale Street.

Dale Street

The image is looking north-east and was taken around 50 yards before North John Street on the right. The street starts at the junction of Castle Street and Water Street outside the Town Hall and ended, at the time of the images, at the junction with Byrom Street and Haymarket where the Great Northern Railway Goods depot was located prior to the building of the Queensway Tunnel entrance. The street contains many buildings of historical interest including the Liverpool, London and Globe Building, Union Marine Buildings, Guardian Assurance Buildings, Magistrates' Courts, Queen's Buildings, State Insurance Building, The Temple, Prudential Assurance Building, Imperial Chambers and the Municipal Buildings.

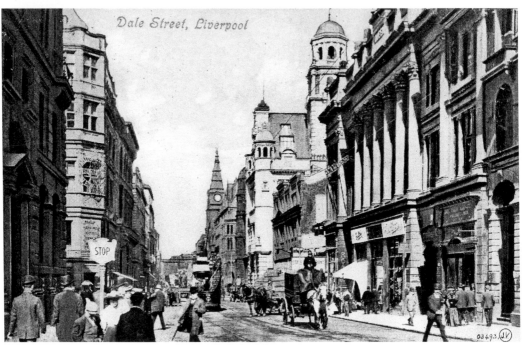

Dale Street, Liverpool

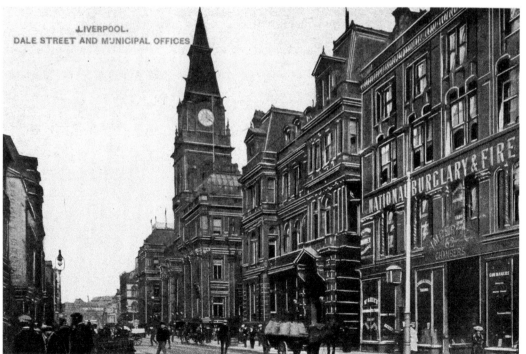

Municipal Building, Dale Street
The building was built by the town council to accommodate the growing number of administrative staff. Work was started in 1860 by Liverpool Corporation surveyor John Weightman, and finished by E. R. Robson in 1866. The building has three storeys and is built of stone with a lead roof. In the centre of the building is a clock and bell tower, which contains five bells. A two-stage pyramidal spire is situated on the top the tower.

DALE STREET AND MUNICIPAL OFFICES.

LIVERPOOL.
DALE STREET AND MUNICIPAL OFFICES

NATIONAL BURGLARY & FIRE

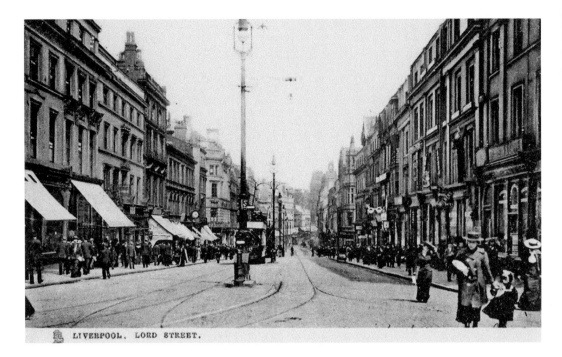

LIVERPOOL. LORD STREET.

Lord Street

The street is approximately 310 yards long and it joins Church Street to the east and Castle Street, alongside Derby Square to the west. These images are taken from near the junction with Derby Square, looking in an easterly direction. Note the tramlines turning to the left of the image above into Castle Street and going ahead into James Street. To the right of the image above the tramlines turn into what was South Castle Street.

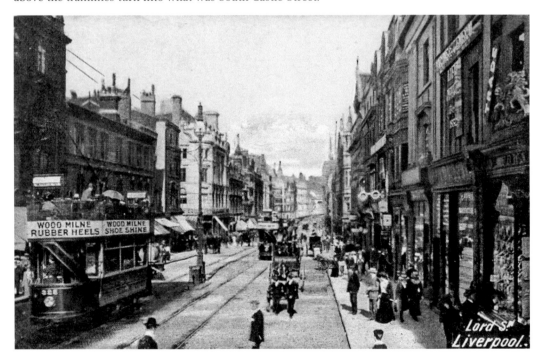

WOOD MILNE RUBBER HEELS WOOD MILNE SHOE SHINE

Lord St Liverpool.

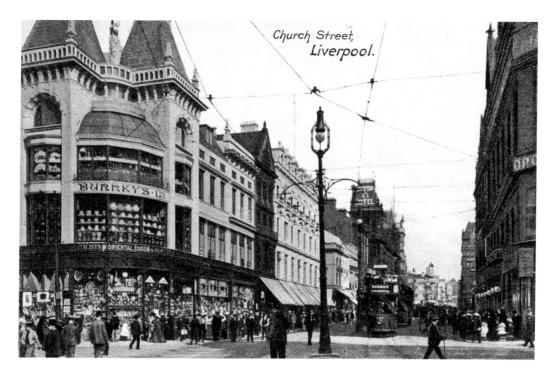

Church Street, Liverpool.

Church Street

The street is a continuation of Lord Street and is approximately 340 yards long, running from Whitechapel to Ranalagh Street in an easterly direction. Both of these images were taken from the corner of Whitechapel and show the famous department store Bunny's on the left foreground, along with the Compton Hotel further down the street on the left.

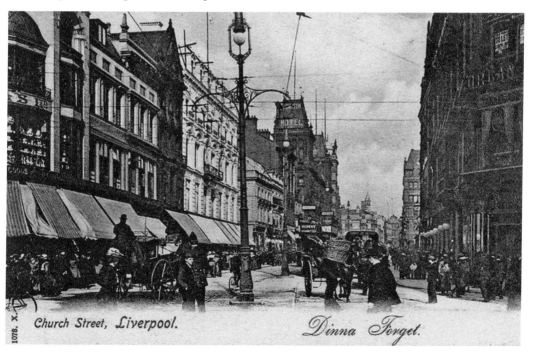

Church Street, Liverpool.

Dinna Forget.

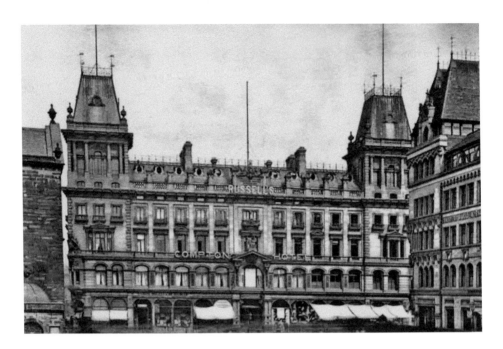

Compton Hotel, Church Street

The original Compton House opened in 1832 and is noted as being one of the first purpose-built department stores in Europe. Rebuilt in 1867 after a fire destroyed the East Asian building two years previously, Compton House was at the time the world's biggest store, having five floors. After the store's closure in 1871 the building was converted into a hotel and renamed Compton Hotel. A decline of Liverpool's economy in the early twentieth century led to the hotel closing in 1927. Retailer Marks & Spencer subsequently moved into Compton House in 1928, with it becoming their flagship store in the city.

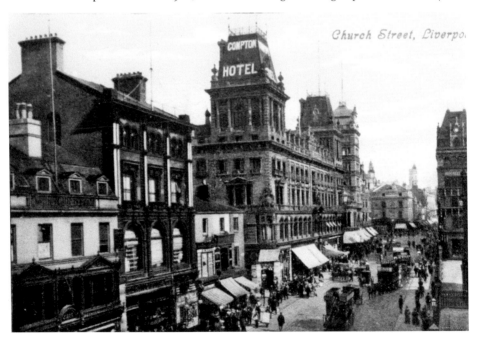

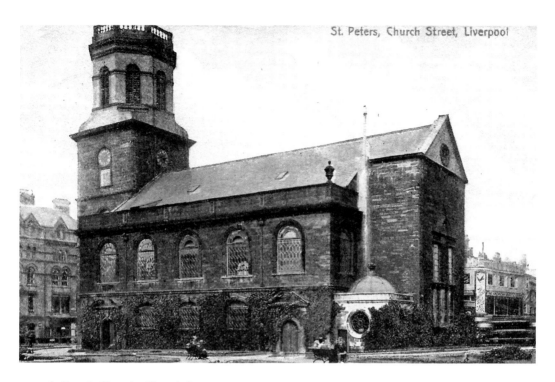

St Peter's Church, Church Street

This church was the Anglican Pro-cathedral and Parish Church of Liverpool. It was erected in 1700, consecrated on 29 Jun 1704 and demolished in 1922. It was located on the south side of Church Street between Church Lane and Church Alley. The church tower was 108 feet high, with its upper part octagonal in shape, and contained a peel of eight bells. The church was replaced as a cathedral by the current Liverpool Cathedral.

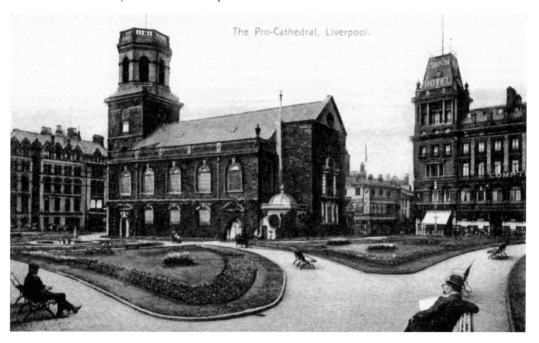

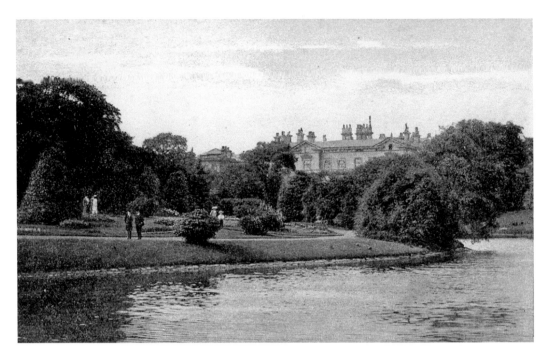

Prince's Park

A total of 90 acres of land were bought from the Earl of Sefton, 50 acres of which were to form the central park, with the remaining land used to build exclusive housing. The park was named after the newborn Edward, Prince of Wales. The central area, including the lake, was for the use of the residents. The park was opened in 1843, but it was not until 1918 that it passed into the hands of the city council and became open to all. The views are looking north with Springbank shown in the image above and Prince's Park Terrace on the image below.

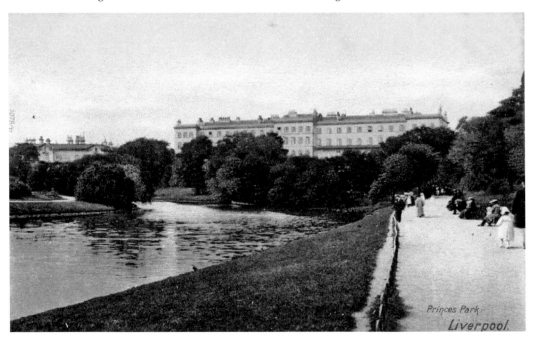

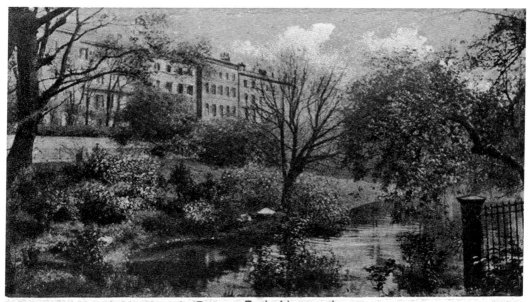

Princes Park, Liverpool.

Prince's Park

This view is from in the park and looking south-east, showing the buildings on Windermere Terrace. The buildings to the left of the images include Culmore, which was bought in 1906, and Silvermere, purchased in 1922 to accommodate flourishing junior and senior departments in the Bellerive Convent FCJ School, which is situated behind these buildings.

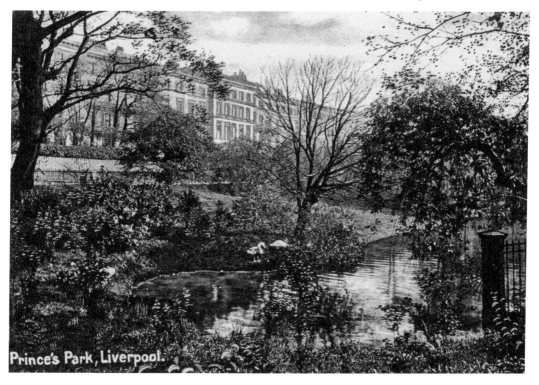

Prince's Park, Liverpool.

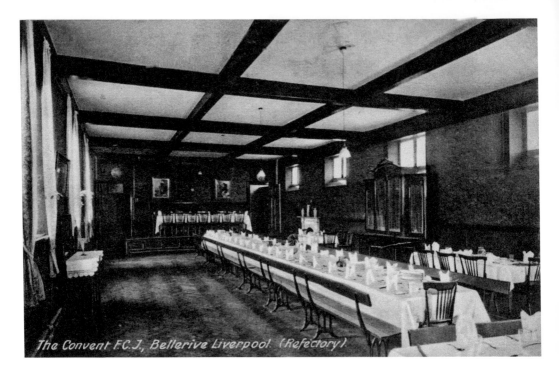

The Convent F.C.J., Bellerive Liverpool. (Refectory).

Bellerive Convent, Prince's Park

The Faithful Companions of Jesus Sisters (FCJ) are a Roman Catholic institute. The Liverpool FCJ School first opened as a boarding establishment for the poor of the city and was located at No. 3 St George's Square. In 1896, the order bought Bellerive in Prince's Park and this building became the hub around which other large houses on the park were taken over as the school expanded. The school is for girls only.

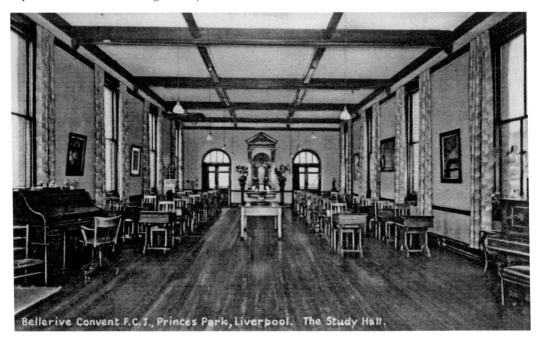

Bellerive Convent F.C.J., Princes Park, Liverpool. The Study Hall.

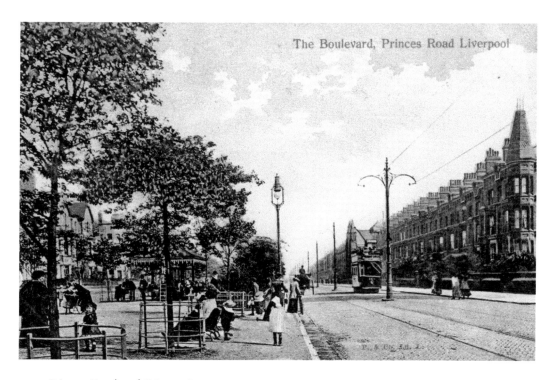

The Boulevard, Princes Road Liverpool

Princes Road and Princes Avenue

This road runs from a traffic island at the northern extremity of Prince's Park –where Croxteth, Devonshire and Kingsley roads join – north-west around 0.64 miles to Upper Parliament Street. It is paralleled along most of its length by Princes Avenue, with a tree-lined strip between them and shelters for tram stops, which ran the length of Princes Road. There were many grand mansions along these roads that were owned by merchants.

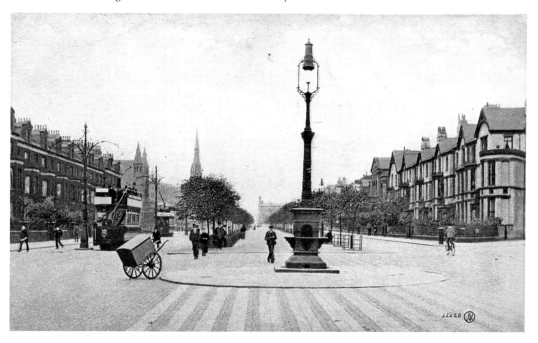

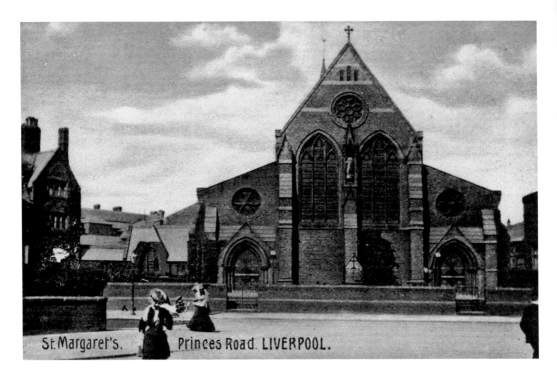

St. Margaret's. Princes Road. LIVERPOOL.

Church of St Margaret of Antioch, Princes Road

This church was built between 1868 and 1869 and was designed by G. E. Street. It was paid for by Robert Horsfall, a local stockbroker and Anglo-Catholic. It was consecrated, appropriately enough, on St Margaret's Day, 20 July 1869. Between 1924 and 1926 the Jesus Chapel, designed by Hubert B. Adderley, was added by extending the north aisle. The existing stained-glass windows were retained and incorporated into the new structure.

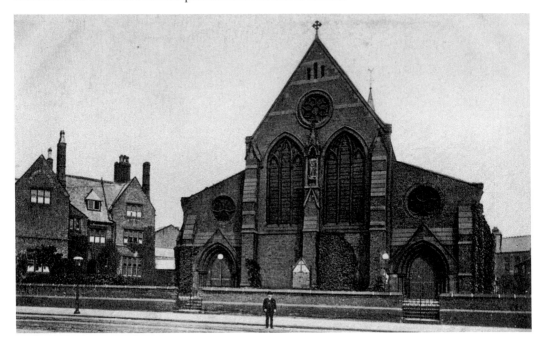

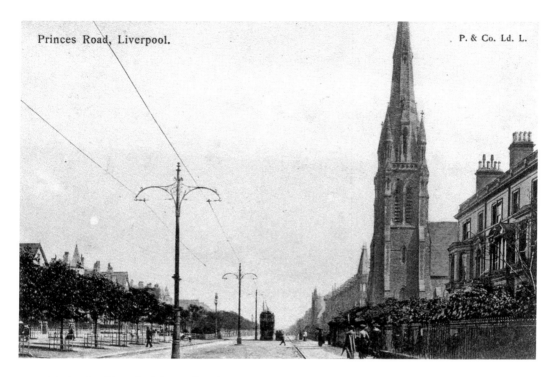

Methodist Church, Princes Road
This Welsh Presbyterian church is located at the junction of Upper Hill Street. The church was built between 1865 and 1867 and designed by the local architects W. & G. Audsley. At the time it was built, because of its steeple rising to a height of 200 feet, it was the highest building in Liverpool.

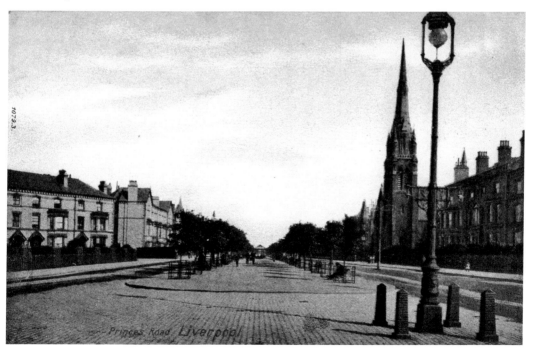

37

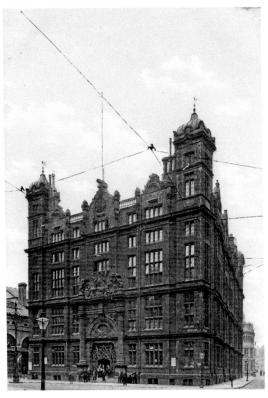

Sailors' Home

Located in Canning Place, the Sailors' Home was designed by John Cunningham and was influenced by Elizabethan houses such as Wollaton and Hardwick Halls. The foundation stone of this palatial lodging house for Liverpool seamen was laid by Prince Albert on 31 July 1846, and the building opened in 1852. A fire swept through the building on 29 April 1860, which closed the building for two years while restoration was carried out.

The interior is modelled upon a ship's quarters, with cabins arranged around five storeys of galleries in the internal rhomboidal court. The columns and balustrades of these galleries were powerfully moulded in cast iron, utilising nautical themes such as twisted ropes, dolphins and mermaids.

The elaborate gate is decorated with a combination of elements from the interior balconies – four great panels of ropework with a central mermaid and trident figures identical to those inside. The two outer panels were fixed while the two centre sections rolled behind them on rails where they were hidden from sight while the home was open for business. The building was closed in 1969 and demolished in 1974.

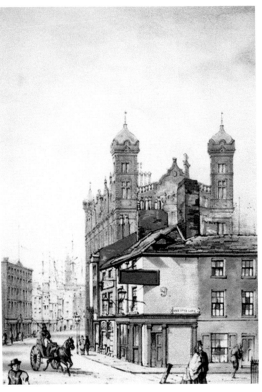

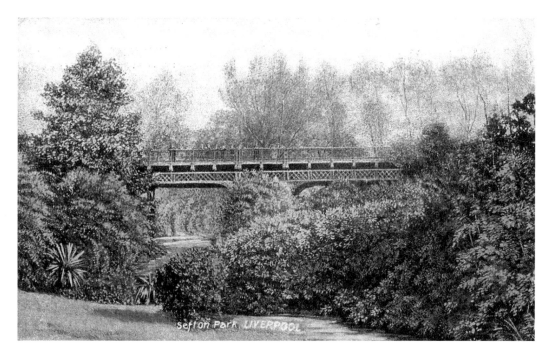

Sefton Park

In 1867, the council purchased 375 acres of land for the development of the park from the Earl of Sefton. The park was opened on 20 May 1872 by Prince Arthur. The park design is based on circular, oval and marginal footpaths framing the green spaces, with two natural watercourses flowing into the 7-acre man-made lake. The Iron Bridge was completed in 1873 near the Queens Drive entrance to Sefton Park, and carries Mossley Hill Drive over Fairy Glen to the north of the lake.

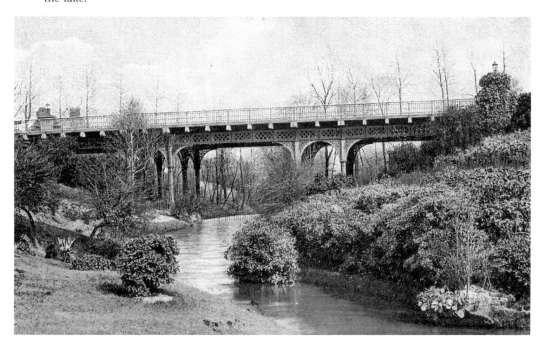

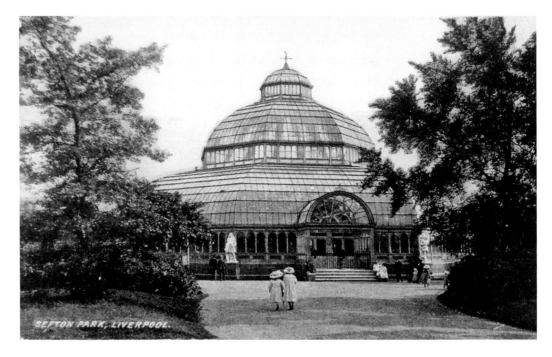

Sefton Park Palm House Exterior

The octagonal, three tier, domed conservatory palm house opened in 1896. Palm House was designed in the tradition of Joseph Paxton's glass houses and at its time of opening was stocked with a rich collection of exotic plants. During the Blitz its glass was shattered by a bomb exploding nearby. It was restored in 1950, but its structural safety deteriorated and was closed on public safety grounds in the 1980s. It was later fully restored and reopened in 2001.

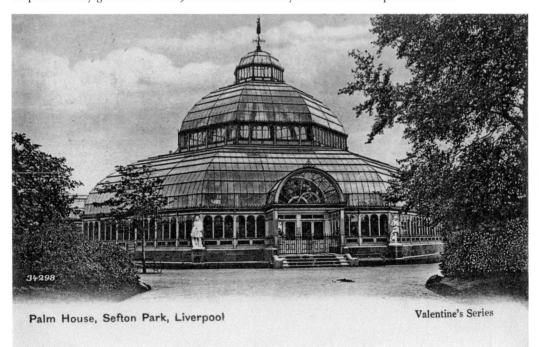

Palm House, Sefton Park, Liverpool Valentine's Series

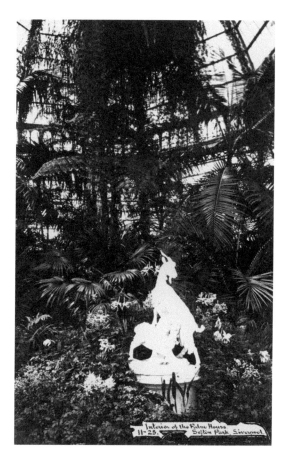

Sefton Park Palm House Interior
Inside the Palm House were sculptures
including *Highland Mary* and *Angels
Whisper* by Benjamin Spence (1822–66),
Two Goats by Lombardi (1837–76),
and *Mother and Child* by Patrick Park
(1822–55). The *Two Goats* statue is shown
on the image to the right and that of
Highland Mary below.

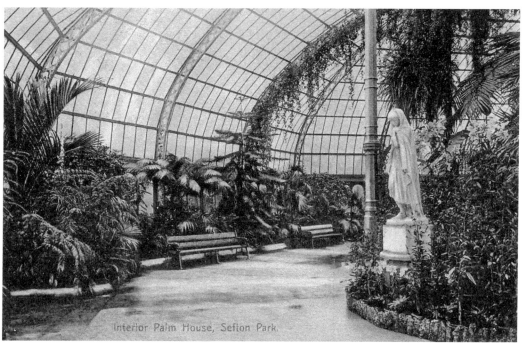

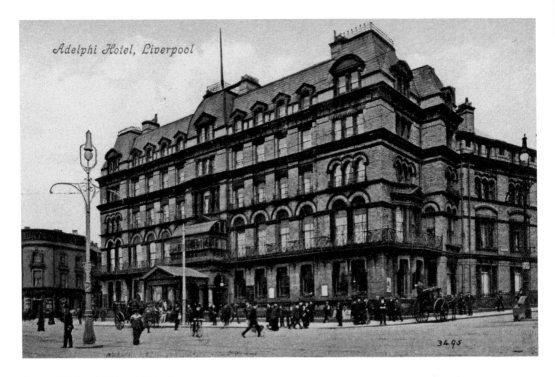

Adelphi Hotel, Liverpool

Second Adelphi Hotel Exterior

In 1826, hotelier James Radley opened a hotel building in Ranalagh Place that was later demolished and replaced by a second hotel in 1896, as shown in these images. The new hotel provided a more luxurious feeling, having over 300 rooms. As well as its famed service it was also known for its turtle soup, prepared from live turtles and kept in heated tanks in the basement. This second hotel was demolished and a third built on the site between 1911 and 1914.

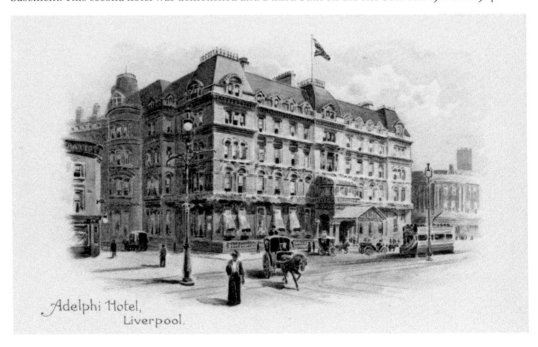

Adelphi Hotel, Liverpool.

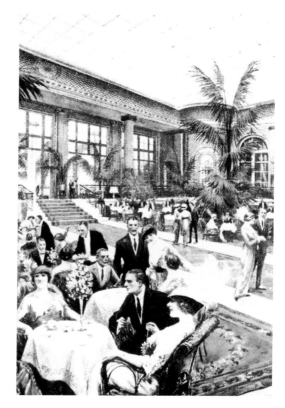

Third Adelphi Hotel Interior

These images show the interior of the third hotel. The new building was designed by Frank Atkinson. Once again, the new building outshone the one that came before. This time the magnificent structure housed a heated indoor swimming pool, tennis and squash courts, Turkish baths, shooting galleries and two restaurants that specialised in both French and English cuisine. What really made the new hotel stand out from the rest was the fact that each room was fitted with a telephone. The public rooms contain columns, marble panelling, and coffered arches. The Central Court, shown on the top left image, is top-lit and contains pink marble pilasters, glazed screens and French doors opening into restaurants on its sides. Beyond this is the Hypostyle Hall, shown on the bottom left image, containing empire-style decoration and four Ionic columns. Beyond this is the Fountain Court.

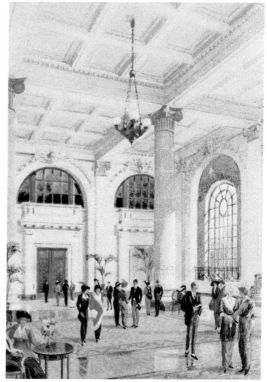

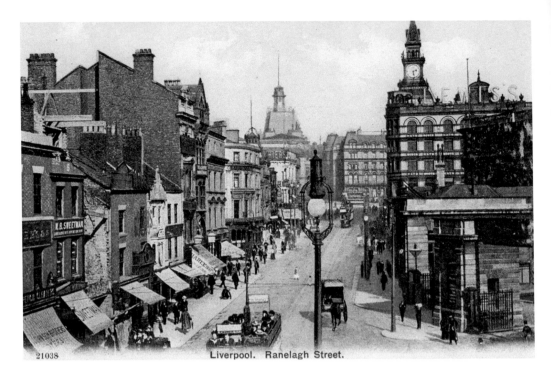

Liverpool. Ranelagh Street.

Ranalagh Street

These images taken of Ranalagh Street, which is approximately 240 yards long, are looking in a north-easterly direction between the junction of Bold Street and Renshaw Street. At the far end of the street can be seen the Adelphi Hotel and the tower of the premises of Jacobs's the tailors – rivals of Lewis's, who also started out as tailors. The Lewis's store is shown with the clock tower. At the bottom right of the images is the Central Station.

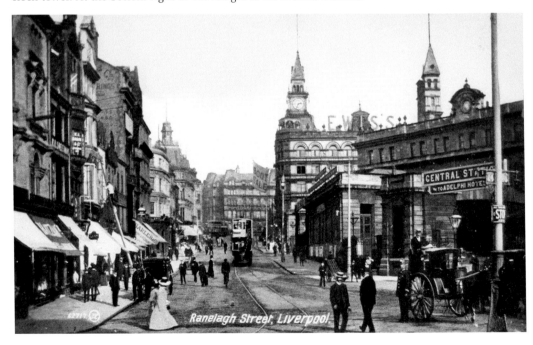

Ranelagh Street. Liverpool.

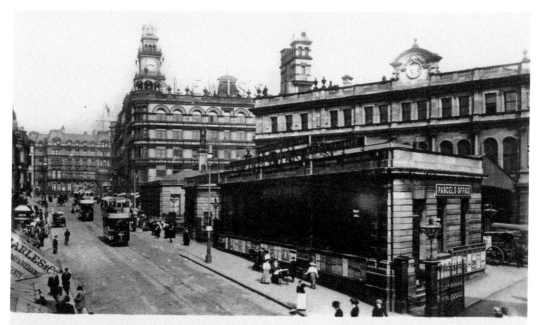

S 2566 CENTRAL STATION AND RANELAGH STREET, LIVERPOOL.

Central Station

Located at the junction of Ranalagh Street and Bold Street and opened on 1 March 1874, Liverpool Central High Level Station was the western terminus of the Cheshire Lines Committee's (CLC) railway, which linked Liverpool and Manchester. On 11 January 1892, Liverpool Central Low Level underground station opened at the end of the Mersey Railway's route. The high-level station closed on 17 April 1972 and the site was later redeveloped. These images are taken looking in an easterly direction from near to the corner of Bold Street.

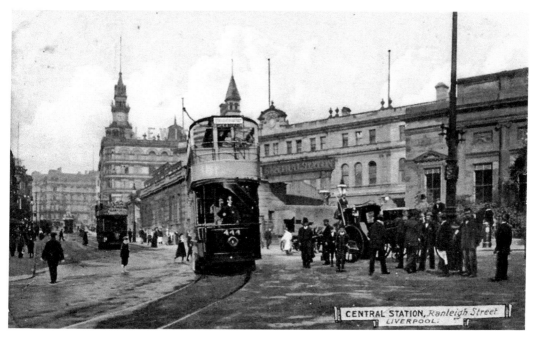

CENTRAL STATION, Ranleigh Street LIVERPOOL.

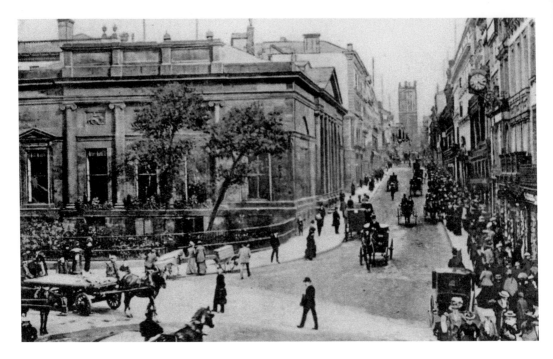

Bold Street

Bold Street was originally laid out as a ropewalk. They used to measure rope from the top of Bold Street to the bottom because it was the standard length needed for sailing ships. The street was laid out for residences around 1780 and named after Jonas Bold, a noted slave merchant, sugar trader and banker. The top image shows the Lyceum on the left, which was constructed in 1802 as a newsroom and England's first subscription library. Both images show St Luke's Church at the end of the street.

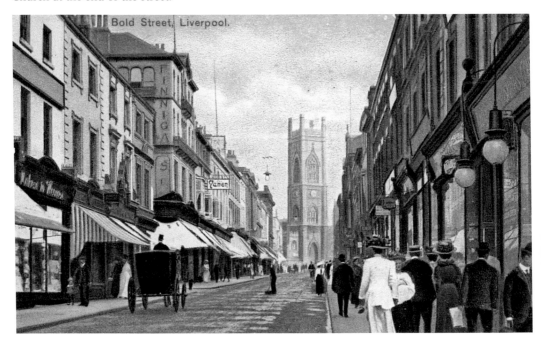

St Luke's Church

St Luke's Church, more commonly known by locals as the bombed-out church, is a former Anglican parish church that stands on the corner of Berry Street and Leece Street, at the top of Bold Street. The church was built between 1811 and 1832 and was designed by John Foster Sr and John Foster Jr, a father and son who were successive surveyors for the municipal Corporation of Liverpool. In addition to being a parish church, St Luke's was also intended to be used as a venue for ceremonial worship by the Corporation and as a concert hall.

Unfortunately, the glory days of the large chapel were not to last as the Second World War swept through the area and the devastating bombing campaign over Liverpool in May 1941 severely damaged the church, completely eliminating its roof. When restoration of the city began the decision was made to leave the church in its ruined state as a memorial to those who died as a result of the war.

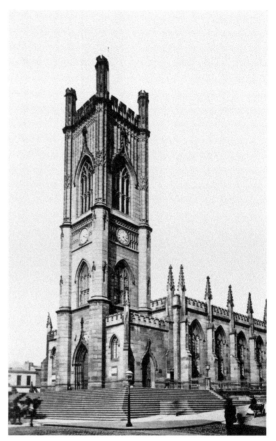

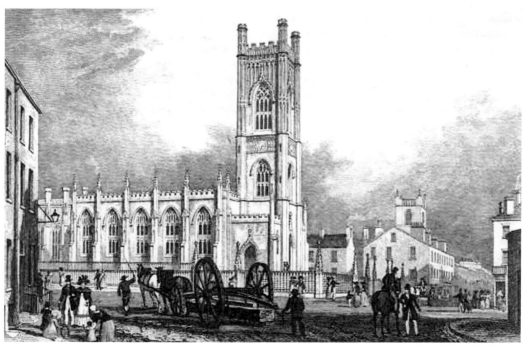

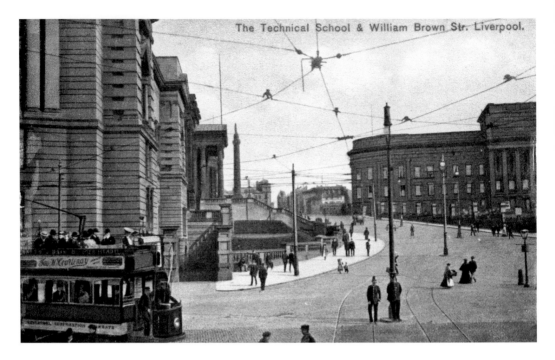

The Technical School & William Brown Str. Liverpool.

William Brown Street

This street, which runs between Old Haymarket and Lime Street, is around 260 yards long and is a testament to Liverpool's exceptional maritime mercantile wealth. It was created through enormous philanthropic and civic investment. The major cultural, educational and civic institutions of the city are located in this area. Key buildings include St George's Hall, the World Museum, Technical School, library, Picton Reading Room and the Walker Art Gallery. The Wellington Monument is also significant.

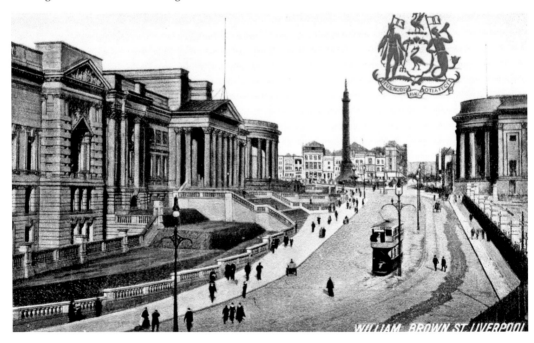

WILLIAM BROWN ST. LIVERPOOL

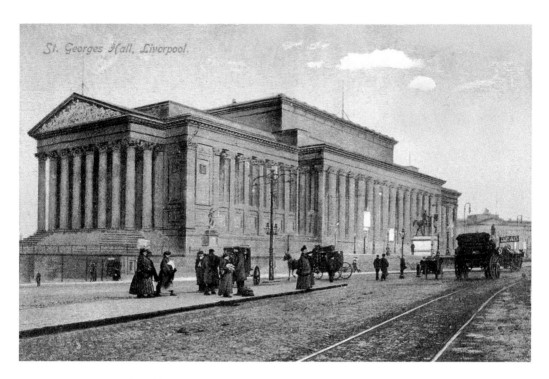

St George's Hall, William Brown Street

Build between 1840 and 1855, the imposing St George's Hall is an outstanding example of European neoclassical architecture. Designed by the young Harvey Lonsdale Elmes, the building combines a concert hall and a courthouse. These images are taken from St George's Place, with William Brown Street running across the background.

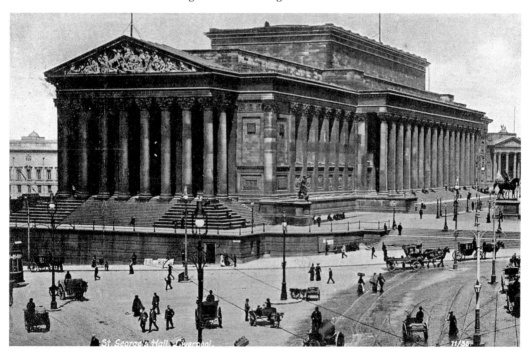

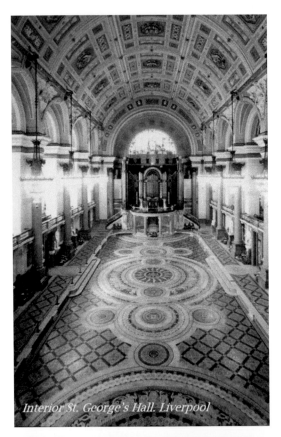

Interior St. George's Hall. Liverpool

St George's Hall, William Brown Street
The Great Hall is richly decorated to celebrate the Corporation of Liverpool and its port. The Minton-tiled floor is decorated with the mythical liver bird, Neptune, sea nymphs, mermaids, dolphins and tridents – symbols of maritime commerce. Statues of Liverpool's great men can be seen on either side of the hall. Many of them were merchants, shipowners and statesmen of the day.

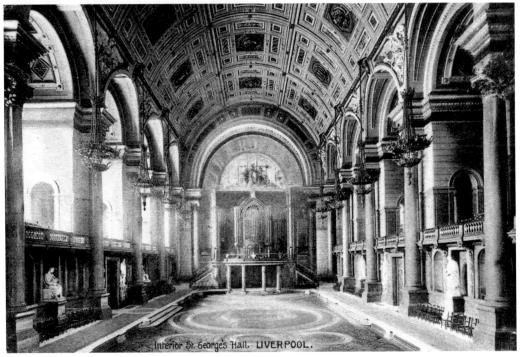

Interior St. George's Hall. LIVERPOOL.

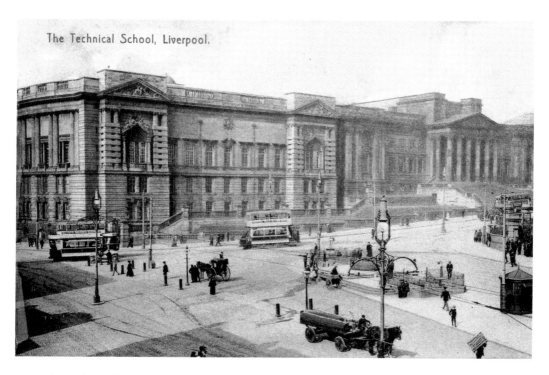

The Technical School, Liverpool.

The Technical School, William Brown Street

The Technical School was built between 1896 and 1901. The building was constructed to provide a new College of Technology and an extension to the museum. The college occupied the lower levels, and the museum the upper levels. The entrance is in Byrom Street, shown on the left of the images.

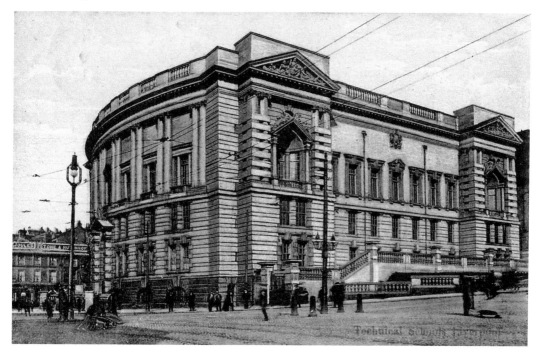

Technical Schools Liverpool

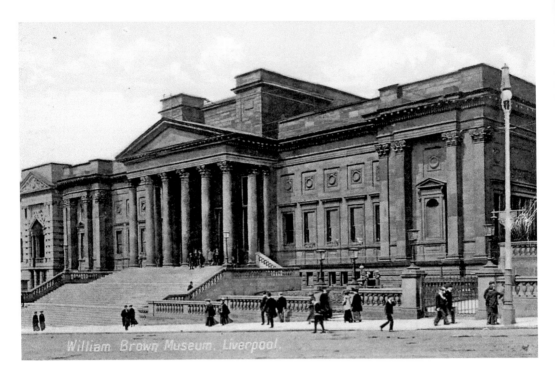

William Brown Street Museum and Library

Following on from the then recently completed St George's Hall across the street, the new building was designed by Thomas Allom in a classical style, including Corinthian columns, and was modified by the Liverpool Corporation architect John Weightman. The new building opened its doors in 1860 with 400,000 people attending the opening ceremony.

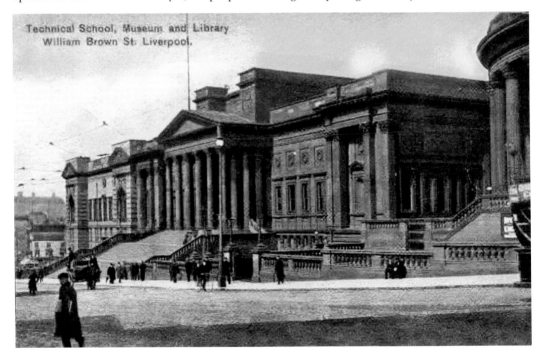

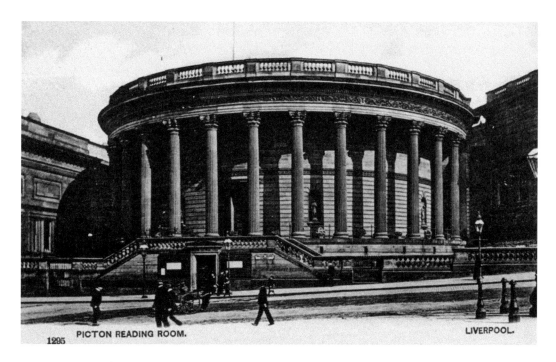

PICTON READING ROOM. LIVERPOOL.
1295

Picton Reading Rooms, William Brown Street

The chairman of the William Brown library and museum, Sir James Picton, laid the foundation stone to the Picton Reading Rooms in 1875. It was designed by Cornelius Sherlock and modelled after the British Museum Reading Room. It was the first electrically lit library in the UK. It was completed in 1879 and formally opened by the mayor of Liverpool, Sir Thomas Bland Royden. The front is semicircular, with Corinthian columns chosen by the architect to cover the change in the axis of the row of buildings at this point.

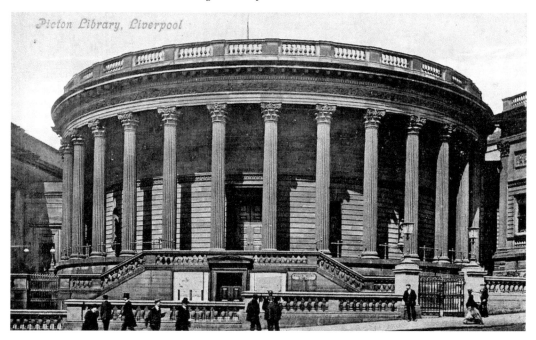

Picton Library, Liverpool

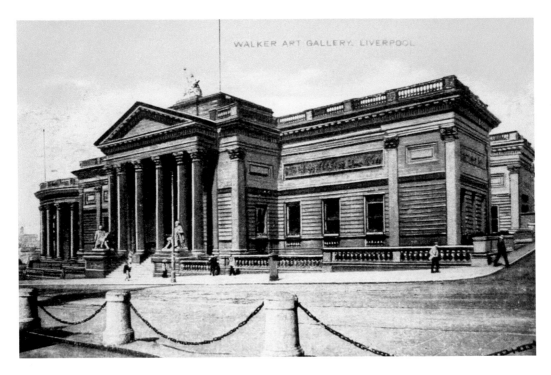

Walker Art Gallery, William Brown Street

Designed by local architects Cornelius Sherlock and H. H. Vale, the Walker Art Gallery was opened on 6 September 1877 by Edward Henry Stanley, 15th Earl of Derby. The gallery was named after its principal benefactor, Alderman Andrew Barclay Walker, who at that time was Lord Mayor of Liverpool.

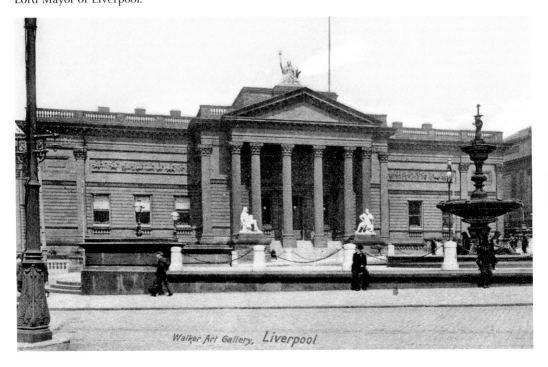

Walker Art Gallery, Liverpool

Wellington Monument, William Brown Street

The Wellington Monument stands on the corner of William Brown Street and Lime Street and is 132 feet high. The monument was funded by public subscription from 1852, but the money was slow in coming and there were delays in choosing the location for it. The foundation stone was laid on 1 May 1861 by the mayor of Liverpool. There was then a further delay due to subsidence on site. Finally, on Saturday 16 May 1863, eleven years after Wellington's death, the inauguration took place. It was handed over to the mayor of Liverpool by Mr John Torr, a local MP and secretary of the Monument Committee. The monument was finally completed in 1865 when the relief panel of the final Battle of Waterloo was erected.

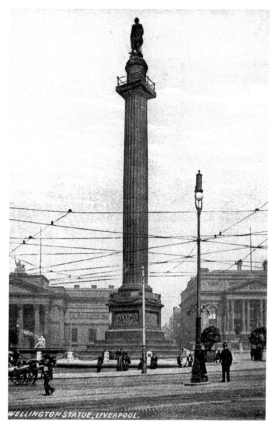

WELLINGTON STATUE, LIVERPOOL.

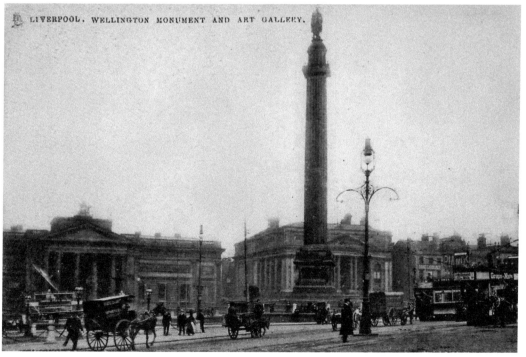

LIVERPOOL. WELLINGTON MONUMENT AND ART GALLERY.

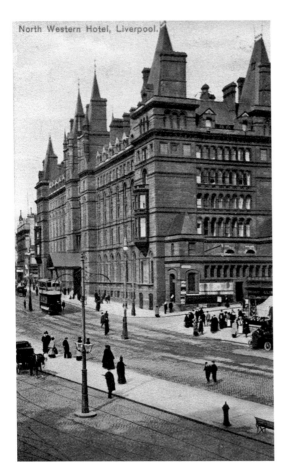

North Western Hotel, Liverpool.

North Western Hotel, Lime Street
The hotel was built in in 1871 as a
railway hotel by the London & North
Western Railway to serve Lime Street
station. The hotel was designed by Alfred
Waterhouse in a French Renaissance
style and contained 330 rooms. It closed
in 1933, subsequently becoming Lime
Street Chambers for a while before
closing once again. It was then renovated
and opened in 1996 as a hall of residence
for John Moores University. In 2018, it
was bought by a hotel chain and will
reopen as a hotel again.

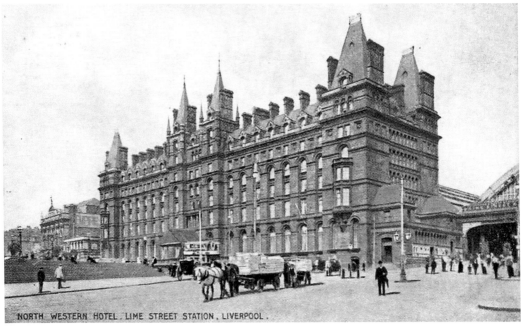

NORTH WESTERN HOTEL, LIME STREET STATION, LIVERPOOL.

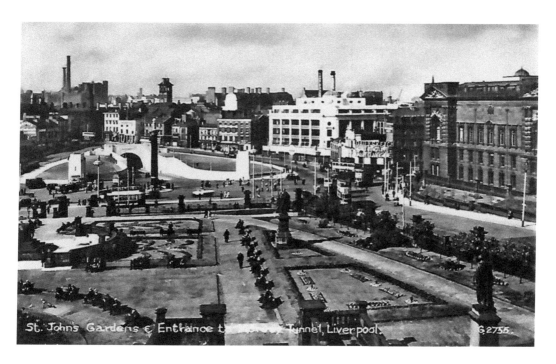

St John's Gardens

These gardens are opposite the museum on William Brown Street and occupy an area that was an old cemetery – it was redeveloped and opened in 1904. The gardens were designed by the Corporation surveyor and, in addition to the creation of flower beds, statues and memorials were erected in the gardens. The gardens stand just to the east of the Queensway Mersey Tunnel entrance, as shown in the images.

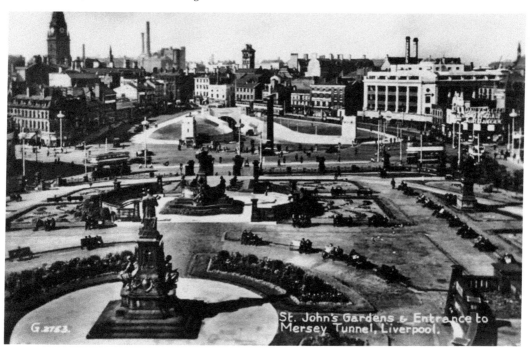

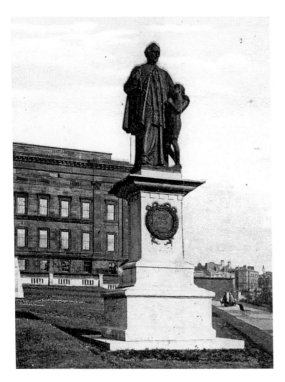

Monsignor Nugent Statue, St John's
Gardens
Nugent was born on 3 March 1822
in Hunter Street, Liverpool. He was
educated in Ushaw College, near
Durham, from 1838 to 1843 before
he became a student at the English
College in Rome. He was ordained to
the diaconate in 1845 and a year later,
on 30 August, he was ordained to the
priesthood at St Nicholas's, Liverpool.
Nugent was a philanthropic priest
whose work with the poor after the Irish
famine, particularly children, earned
him the love and respect of the people
of Liverpool. This statue, sculptured by
F. W. Pomeroy, was unveiled in St John's
Gardens on 8 December. It consists of a
bronze figure in the pose of blessing and
a ragged boy, both standing on a stone
pedestal decorated with a bronze wreath.

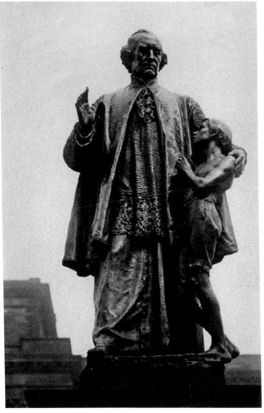

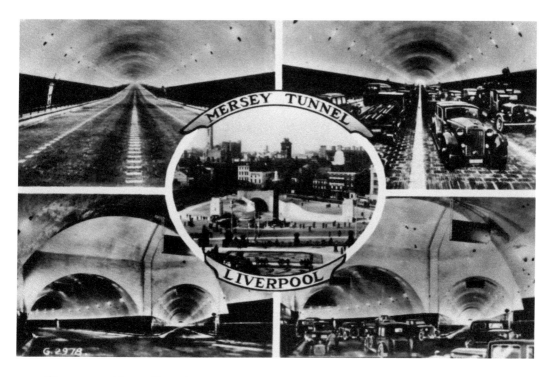

Queensway Mersey Tunnel

Before the tunnel was built the only way to cross the Mersey by vehicle was to queue for a special vehicle ferry, which often didn't run because of the weather conditions. The construction of the tunnel began in 1925 from both sides of the river, with the two pilot tunnels meeting in 1928. Construction of the tunnel required the excavation of 1,200,000 tons of rock and gravel and the building of 2 miles of roadway using 82,000 tons of cast iron and 270,000 tons of concrete.

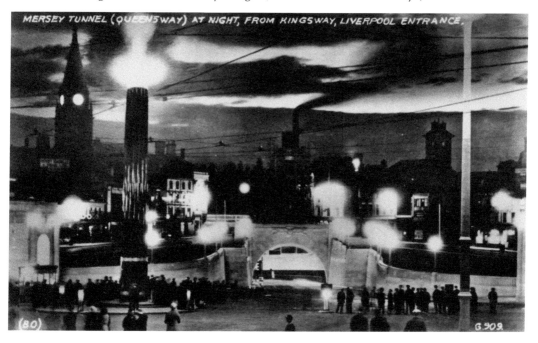

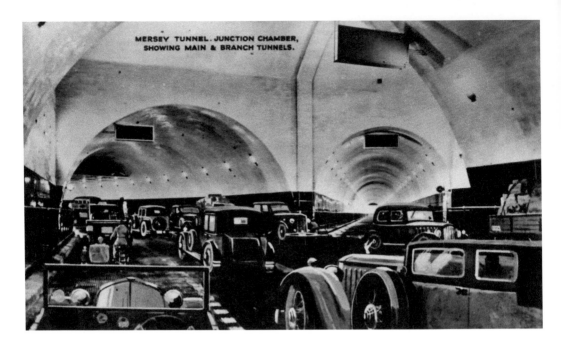

MERSEY TUNNEL. JUNCTION CHAMBER, SHOWING MAIN & BRANCH TUNNELS.

Queensway Mersey Tunnel

The tunnel is split into two sections, with the upper level being used to carry the road traffic. The lower section, known as Central Avenue, is directly under the two central lanes of traffic and was originally intended to house a tramway, but this idea never came to fruition as other forms of transport became more popular. The tunnel was opened on 18 July 1934 by George V after almost nine years of work, and over 200,000 people gathered in Old Haymarket to watch the opening ceremony. The royal car led the way through the tunnel to Birkenhead where 3 miles of crowds waited.

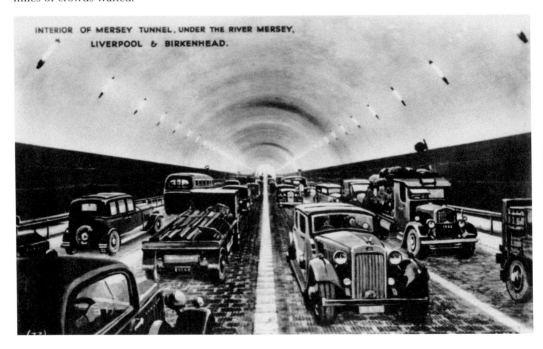

INTERIOR OF MERSEY TUNNEL, UNDER THE RIVER MERSEY, LIVERPOOL & BIRKENHEAD.

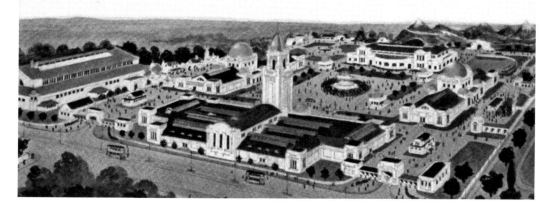

General View, Liverpool Exhibition

Liverpool Exhibition, Wavertree

Land adjacent to the Botanic Gardens in Edge Lane was used for the 1913 Liverpool Exhibition. The event was conceived to counter the city's negative image after the 1909 sectarian riots and the 1911 transport strike. The exhibition was not a success and Liverpool Exhibition Ltd went into receivership within a few months of opening. The scenic railway was also subject to an arson attack by suffragettes. The tournament hall to the left of the image above was converted into the Carnival Hall and Palais to serve the exhibition.

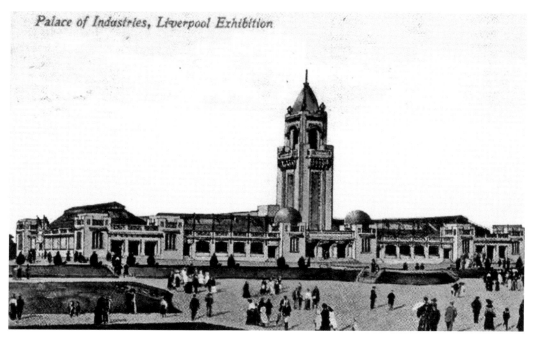

Palace of Industries, Liverpool Exhibition

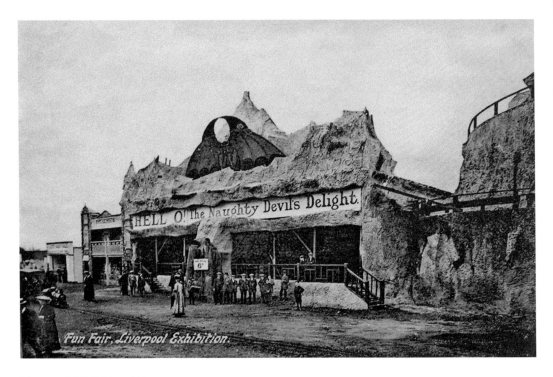

Fun Fair, Liverpool Exhibition.

Liverpool Exhibition, Wavertree

The event featured a 400-foot-long industrial exhibition, sideshows, a massive collection of wild animals, a pleasure fair and the largest and longest scenic railway in the world constructed, all at a cost of around £10,000, which at the time of writing is equivalent to approximately £1.2 million.

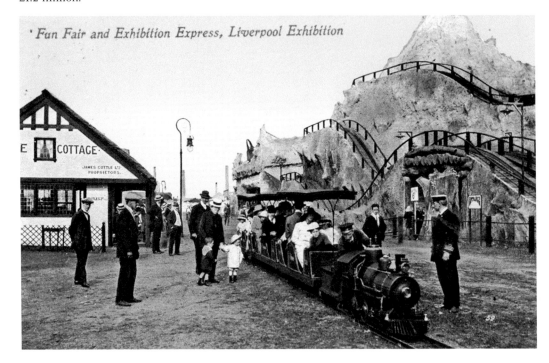

Fun Fair and Exhibition Express, Liverpool Exhibition

The Old Mill, Wavertree

The mill was located near the old quarry on what was then the access road and is now Beverley Road. First recorded in 1452, the Wavertree Windmill was one of only four 'King's Mills' in Liverpool. For nearly 200 years it was the property of the Crown, until in 1639 Charles I granted it to Lord Strange, a son of Lord Derby. By the eighteenth century the ownership of the mill had passed to Bamber Gascoyne, tenant of Childwall Hall. It then passed to the Marquess of Salisbury and finally was leased by Colonel James Bourne of Heathfield. The mill was wrecked in a storm in 1898. It was demolished in 1916.

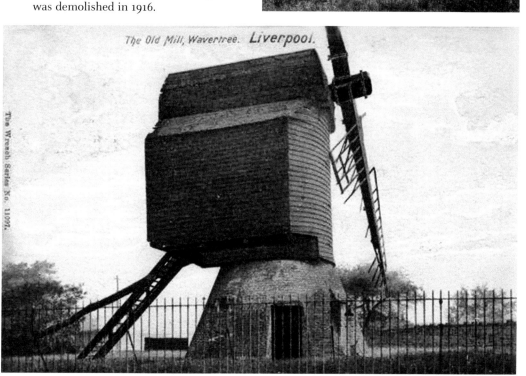

The Old Mill, Wavertree, Liverpool.

The Old Mill, Wavertree. *Liverpool.*

The Wrench Series No. 11097.

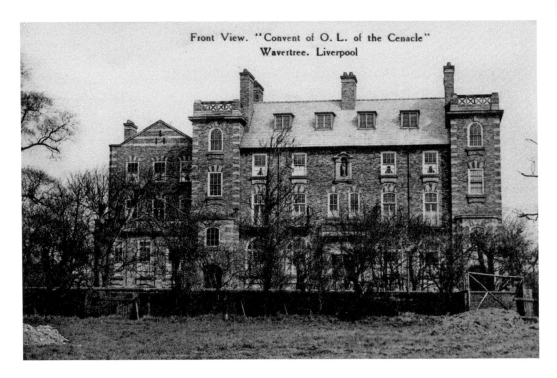

Front View. "Convent of O. L. of the Cenacle" Wavertree. Liverpool

Convent of Our Lady of the Cenacle, Wavertree

Before becoming a convent in 1911 this large mansion was called 'The Elms', being situated on Lance Lane. The order stemmed from the work of a secular priest, Jean Pierre Etienne Terme, who was born in France in 1791. Its mission was to cater for the spiritual needs of the poor, mainly those of women and children.

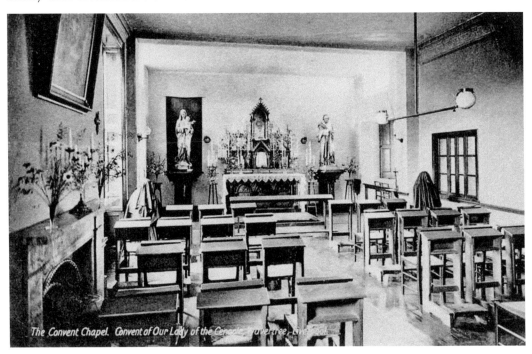

The Convent Chapel. Convent of Our Lady of the Cenacle, Wavertree, Liverpool.

St Mary's Church, Wavertree

St Mary's Church is located at the junction of North Drive and South Drive, which are in the Victoria Park residential estate. The new Wesley church was erected in 1873. Its location was usually given as Victoria Park, Wavertree, although it actually stood in the Olive Vale area. Various additions, including a spire, were subsequently made. The First World War inflicted heavy losses on the church, and, although renovated in 1925, it continued to exist with difficulty until it was finally closed in 1950. It was sold to the Church of England who converted it for use as an Anglican church.

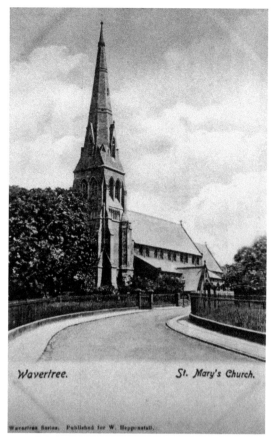

Wavertree. St. Mary's Church.

Wavertree Series. Published for W. Heppenstall.

VICTORIA PARK, WAVERTREE.

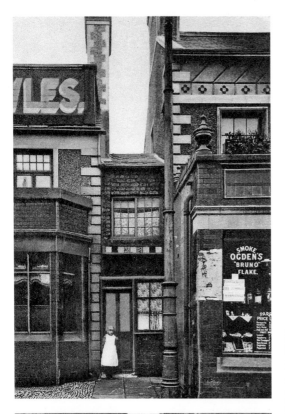

Smallest House in England, Wavertree
Situated at No. 95 High Street, the house
is only 6 feet wide. The tiny property
was reportedly built in 1850 in the
passageway space between a temperance
coffee house and its neighbouring
property. At 6 feet wide and 14 feet
long, it was reputed to be the smallest in
England. The last occupant moved out in
1925 and it was eventually absorbed into
the pub in 1952.

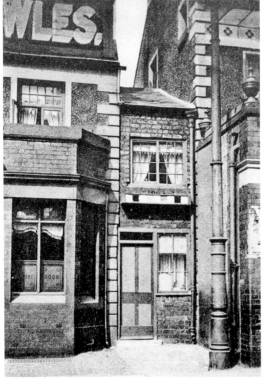

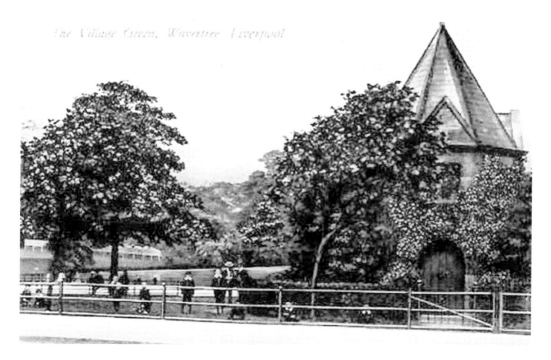

The Village Green, Wavertree

The village green, on which Wavertree's lock-up was built, is officially the only surviving piece of common land in Liverpool. Located on the green and shown in these images is the village lock-up, commonly known as The Roundhouse, despite being octagonal in shape. Built in 1796, it was later modified by prominent local resident and architect Sir James Picton. It was once used to detain local drunks.

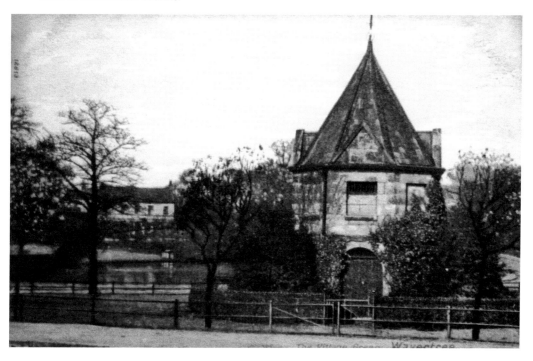

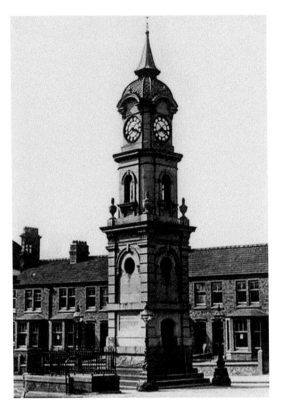

Picton Clock Tower, Wavertree

The clock tower was constructed as a memorial in 1884 by Mr James Picton. The memorial is to Picton's wife, Sarah Pooley, who died tragically in 1879 after some fifty years of marriage. It was situated at the junction of High Street, Childwall Road and Church Road North so that the maximum amount of people would be able to see this great piece of architecture. Renaissance in its style, the tower consists of three sections mounted upon a rusticated base and surrounded on four sides by iron street lamps that feature dolphins at their base. On the lower-section walls there are three stone plaques on each side and an access door to the tower; above these are roundels with urns at each corners. Above these are round-headed windows, which are topped with a clock face in each direction. At the very top of the tower is a spire with lead cupola.

Wavertree

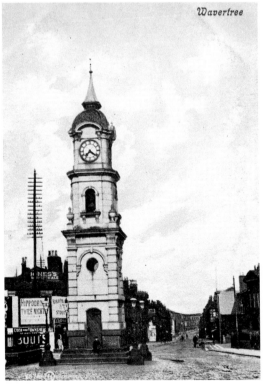

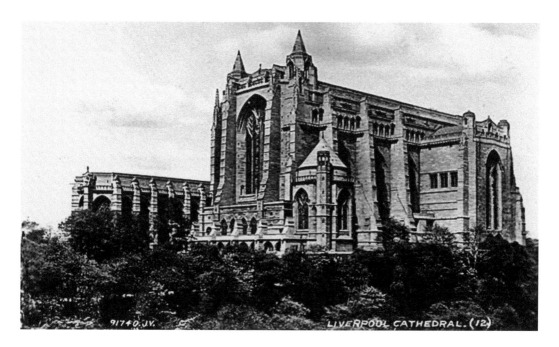

Anglican Cathedral

The building is located on St James Mount. The building was the vision of architect Sir Giles Gilbert Scott. The foundation stone was laid by Edward VII in 1904. The first section of the main body of the cathedral, shown in the above image, was completed and consecrated on 19 July 1924. Major works ceased for a year while Scott once again revised his plans for the next section of the building, the tower, the under-tower and the central transept. In his final design the single tower was higher and narrower than his previous plan. The original plan, though, had envisaged two towers. The image below shows the building when the tower was completed.

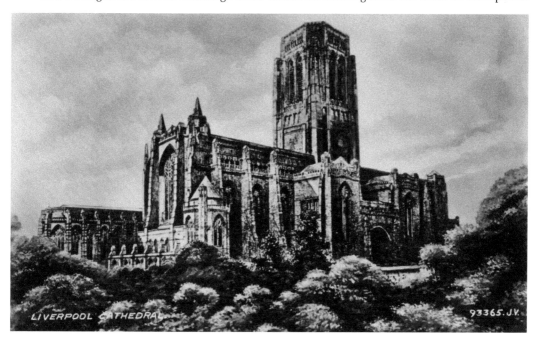

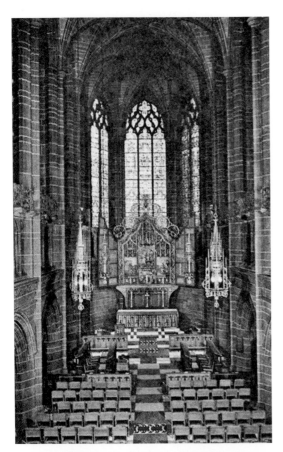

Anglican Cathedral

Despite delays due to the Second World War the tower was completed and handed over on 20 February 1942. Scott produced his plans for the nave in 1942, but work on it did not begin until 1948. Scott died in 1960 and did not see the completion of the building, which was marked by a service of thanksgiving and dedication in October 1978 attended by the Queen.

The two images show the Lady Chapel, the first part of the building to be completed, which was consecrated on 29 June 1910. This date, which was St Peter's Day, was chosen to honour the pro-cathedral, which was due to be demolished.

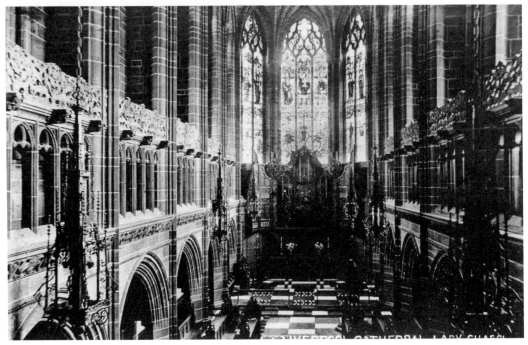

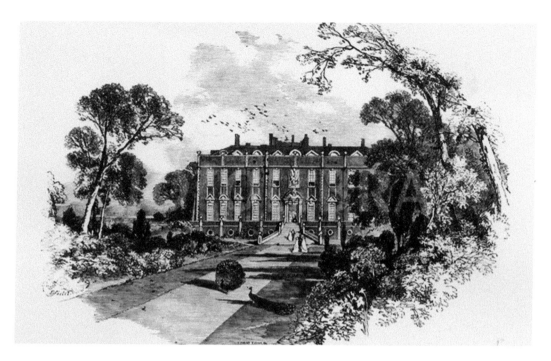

Croxteth Hall

The original building dates from 1575 and the last building was completed in 1902. The original building was gradually extended, with each part built in a way that it blended with the previous part. The image below is of all the staff and workers from the Croxteth Hall estate, who attended a party held for them on 26 May 1920 for the twenty-first birthday of Hugh William Osbert Molyneux, the 7th – and last – Earl of Sefton. When the earl died in 1972 the estate passed to Liverpool City Council.

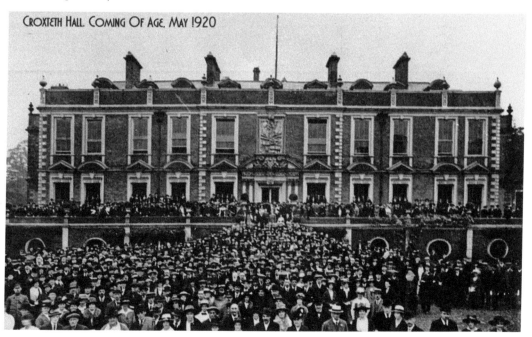

CROXTETH HALL. COMING OF AGE. MAY 1920

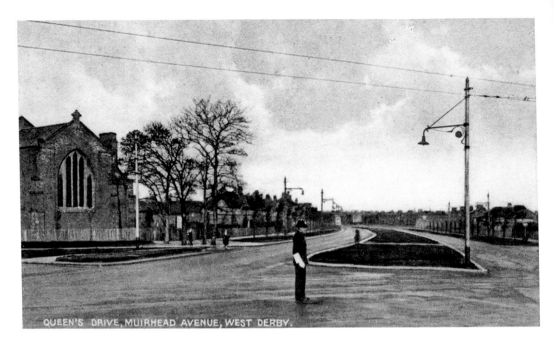

QUEEN'S DRIVE, MUIRHEAD AVENUE, WEST DERBY.

Queens Drive and Muirhead Avenue, West Derby

Queens Drive has been described as being the first ring road to be built in the country and was designed around the idea that future growth would require a substantial road. These images are taken from the junction with Muirhead Avenue, which has a very wide central reservation. The above image is looking north-west with Adshead Road and St Andrew's Clubmore Church on the left. The image below is looking south-west along Muirhead Avenue, showing just one carriageway with the central reservation to the left. Both images show the new housing development in the area.

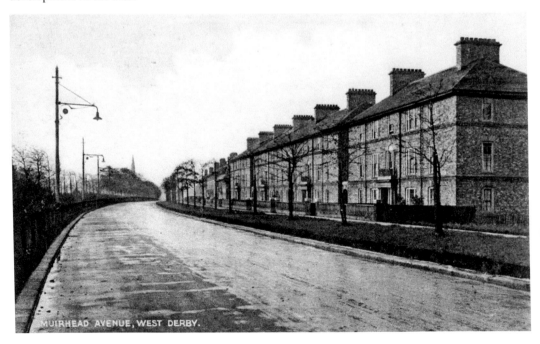

MUIRHEAD AVENUE, WEST DERBY.

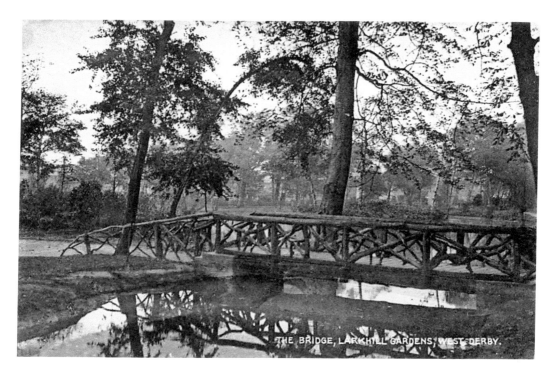

THE BRIDGE, LARKHILL GARDENS, WEST DERBY.

Larkhill Gardens, West Derby

Larkhill Gardens are situated on Malleson Road and consist mainly of an ornamental lake, which originally was in the grounds of the old Larkhill Hall. When the estate was built it was decided that the lake and the tract of land around it should be made into a public garden for all the residents of the new estate to enjoy. Tue Brook is reputed to feed the pond in the gardens.

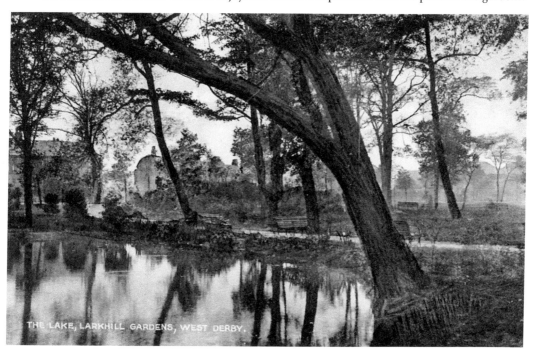

THE LAKE, LARKHILL GARDENS, WEST DERBY.

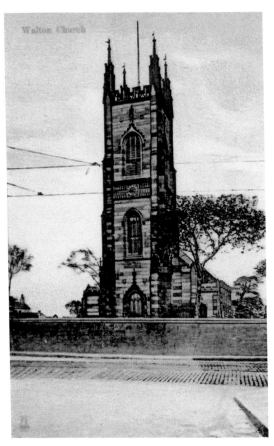

Walton Church

The oldest part of the present church is the west tower, which was built between 1829 and 1832 to a design by John Broadbent, a pupil of Thomas Rickman. The north side of the church was remodelled in 1840, and the chancel was rebuilt in 1843. In 1911, a south aisle incorporating a chapel, an ambulatory and a vestry were added by Nagington and Shennan. Most of the church, apart from the tower, was destroyed by incendiary bombs in the Blitz of May 1941.

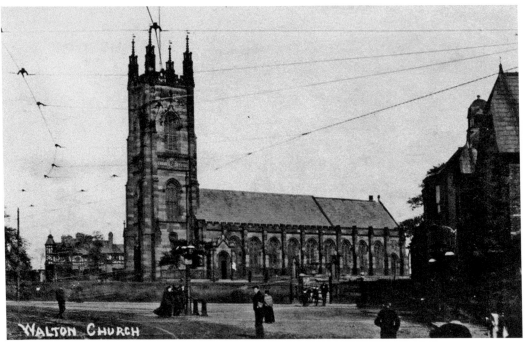

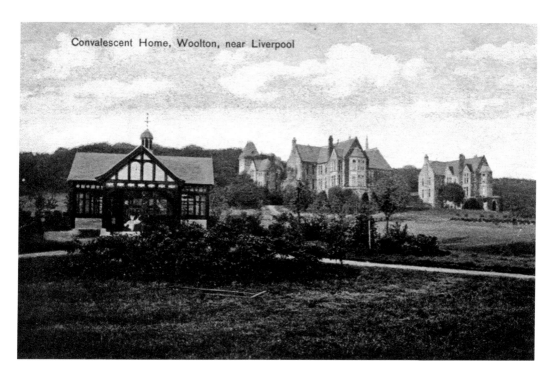

Convalescent Home, Woolton, near Liverpool

Convalescent Home, Woolton

This is a brick-built, Gothic Revival-style hospital built in 1869 with 20 acres of grounds and designed by Thomas Worthington. It was made from the surplus of the Liverpool fund for the relief of the Cotton Famine in 1862. It was intended chiefly for patients who had been treated at the Liverpool hospitals, but there was also a wing for private patients.

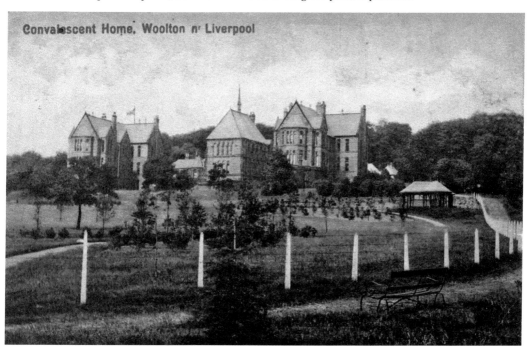

Convalescent Home, Woolton n' Liverpool

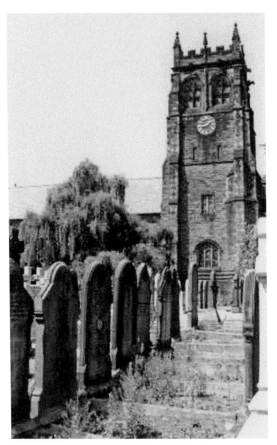

St Peter's Church, Woolton

The cornerstone for the current church was laid in 1886 and it was built from local sandstone. The 90-foot-high bell tower contains eight bells and is the highest point in Liverpool, with views of Merseyside, Lancashire, Cheshire and the Welsh hills. The new church was designed by the local architects Grayson and Ould, and was completed in 1887. St Peter's Church is most famous for being the location where John Lennon met Paul McCartney on 6 July 1957. The church graveyard provides the final resting place for 'our' Eleanor Rigby, as well as John Lennon's uncle, George Toogood Smith, and Bob Paisley, said to be the most successful manager in the history of Liverpool Football Club.

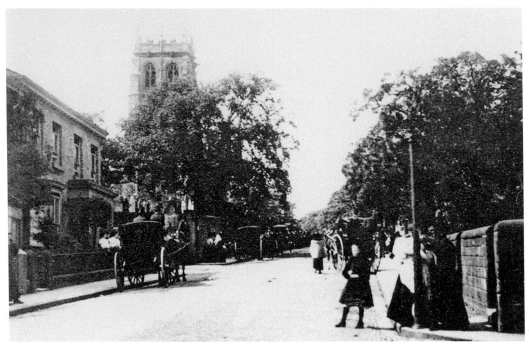

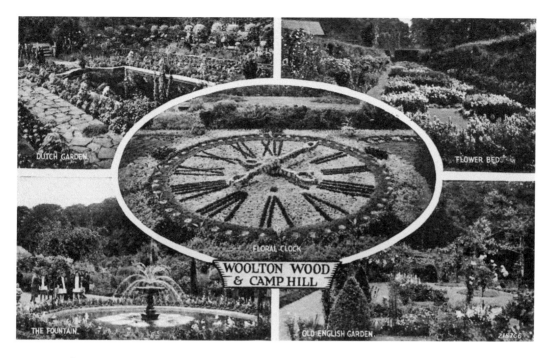

Woolton Wood and Camp Hill

Woolton Wood originally formed part of the estate of Woolton Hall, which from 1772 was owned by the Ashton family, prominent Liverpool citizens, the earliest of whom can be traced back to the sixteenth century in Liverpool. In 1927, Col Reynolds inaugurated the famous Floral Cuckoo Clock presented to the public by the family of James Bellhouse Gaskell in memory of his long connection with Woolton Woods.

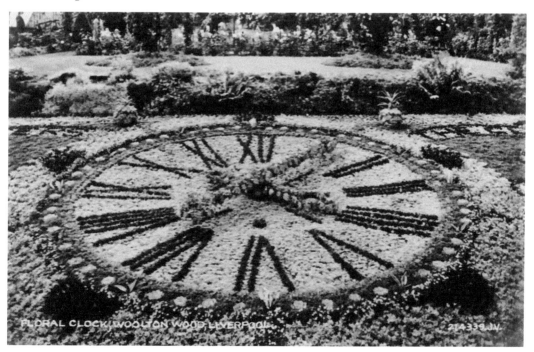

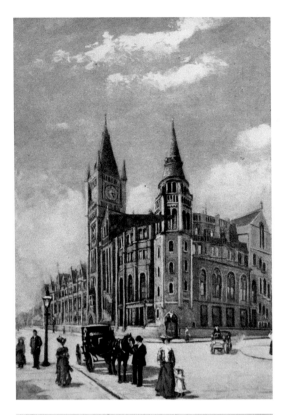

Victoria Building, University College
The building is located on the corner of Brownlow Hill and Ashton Street. It was designed by Alfred Waterhouse and completed in 1892. The builders were Brown and Backhouse, and the brickwork was contracted to Joshua Henshaw & Sons. Victoria Building was officially opened in December 1892 by Lord Spencer, the chancellor of the Victoria University located in Manchester.

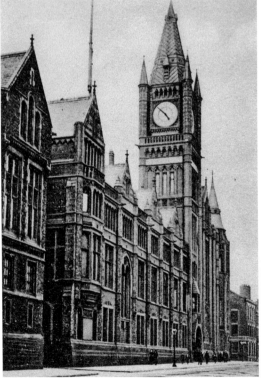

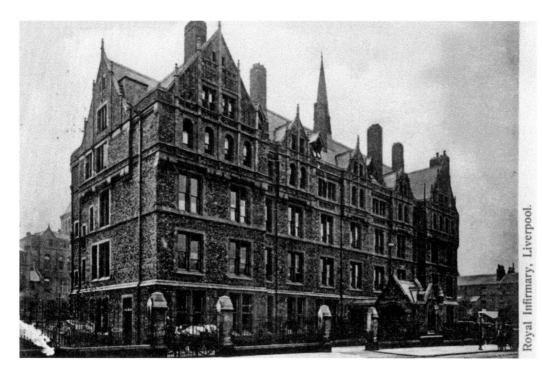

Royal Infirmary

Situated at the top of Brownlow Hill, the Royal Infirmary opened in November 1889. In 1885, Sir Alfred Waterhouse was commissioned to submit plans for the new Liverpool Royal Infirmary. He corresponded with Florence Nightingale, and she succeeded in influencing some of his designs, including the wards, their height and number of beds to ensure sufficient daylight and ventilation.

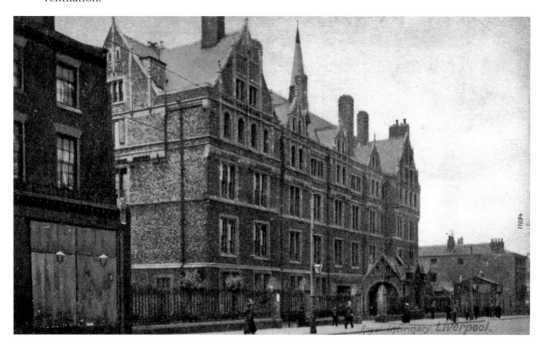

Royal Infirmary Liverpool.

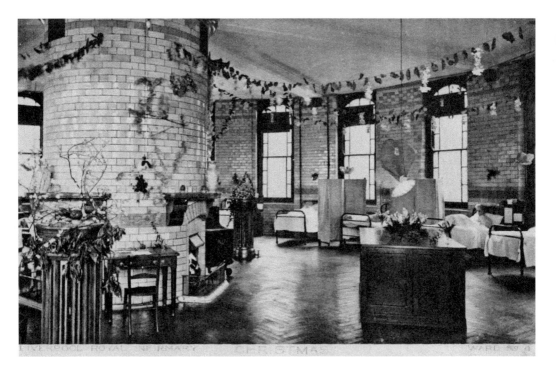

Royal Infirmary

These images show how the beds were laid out well in a spacious ward with lots of natural light and ventilation. Both show wards decorated for the Christmas period. The image above is of Ward 4 and the one below is of Ward 12.

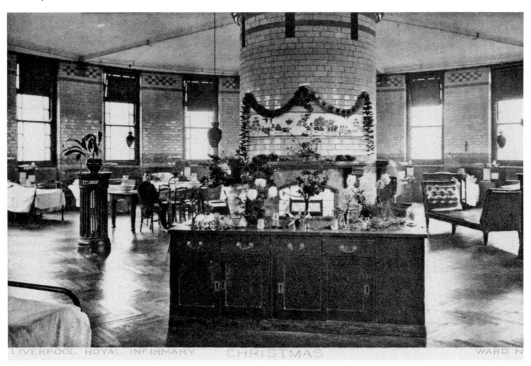

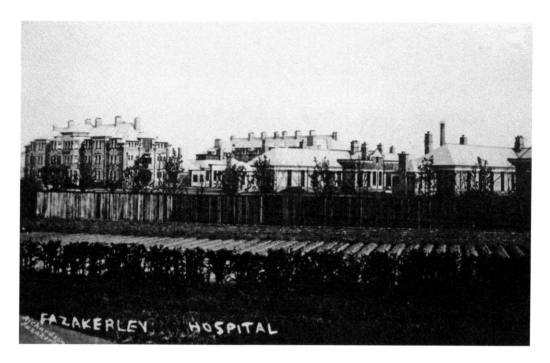

Fazakerley Hospital

In 1898, Liverpool Corporation acquired land from the Harbreck estate to build a hospital, initially known as the City Hospital North, Fazakerley, for Infectious Diseases. The hospital opened in 1906. During the First World War, the building was requisitioned by the War Office to create the '1st Western General Hospital', a facility for the Royal Army Medical Corps. It became the Fazakerley Infectious Hospital in 1947 and, after joining the National Health Service in 1948, became the Fazakerley Hospital in 1968.

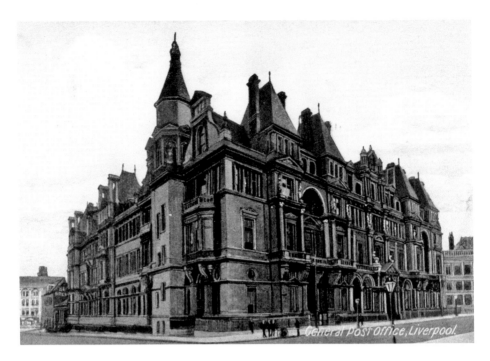

General Post Office

The new post office in Victoria Street was opened in July 1899 by the Duke of York. The building has a frontage to Victoria Street of 226 feet, to Sir Thomas Street of 254 feet and to Stanley Street of 260 feet. It has a yard that is 103 square feet. The site covers nearly 2 acres of ground. In front of the second floor there are four figures representing England and Scotland, and Ireland and Wales, the two pairs standing hand in hand. There are ten smaller figures representing colonies.

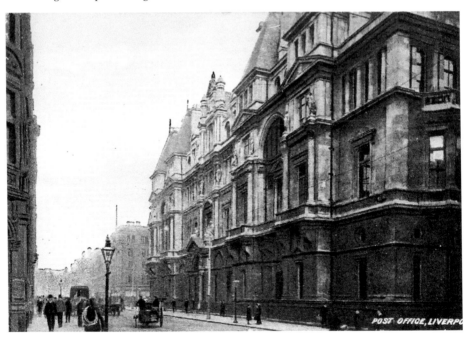

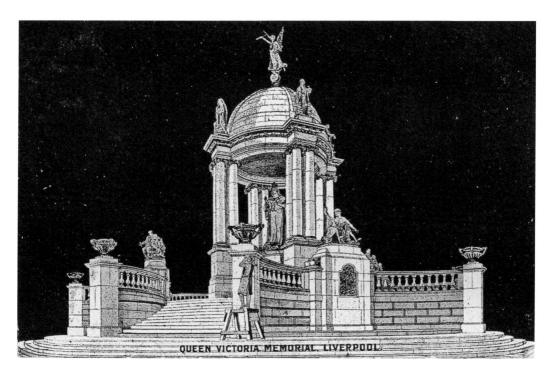

QUEEN VICTORIA MEMORIAL. LIVERPOOL

Queen Victoria Monument

The foundation stone was laid on 11 October 1902 by Field Marshal Lord Roberts, commander-in-chief of the forces. The monument was unveiled on 27 September 1906. The Queen Victoria Monument is a large monument built on the former site of Liverpool Castle, located at Derby Square in Liverpool. It features twenty-six bronze figures by C. J. Allen, including a 14.5-foot-high statue of Queen Victoria in the centre.

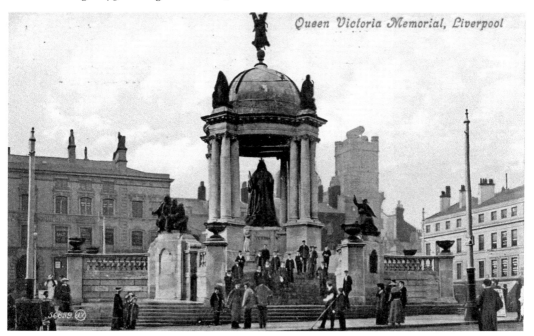

Queen Victoria Memorial, Liverpool

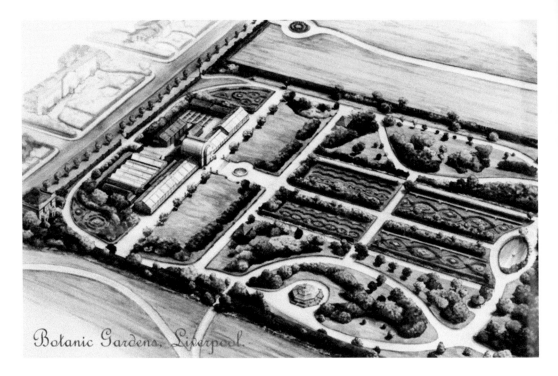

Botanic Gardens, Liverpool.

Botanic Gardens

Located in Edge Lane, the then private walled botanic garden opened in 1836. The gardens were taken into the charge of the local authority in 1846 with the early nineteenth-century layout still in place. The Botanic Gardens are surrounded by a public park, which opened in 1856 and was extended in the late nineteenth century. It forms one of the earliest of an inner ring of public parks developed in Liverpool in the mid-Victorian period.

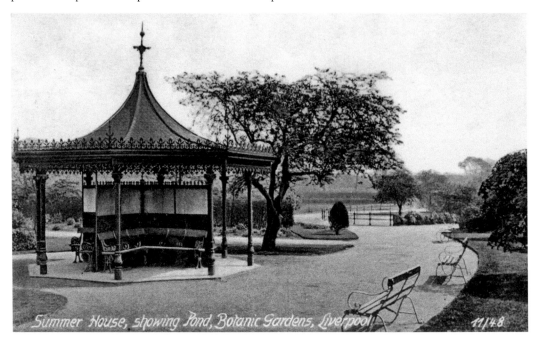

Summer House, showing Pond, Botanic Gardens, Liverpool.	11/48

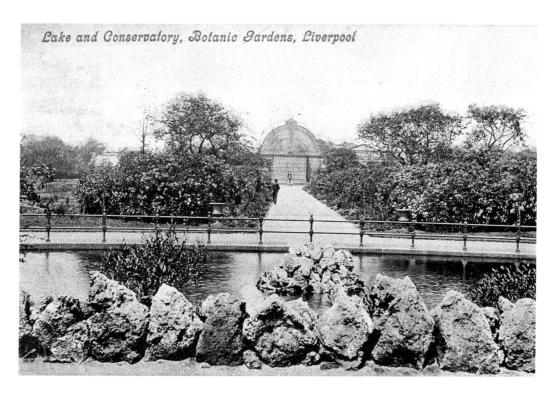

Lake and Conservatory, Botanic Gardens, Liverpool

Botanic Gardens

The above image is taken looking north from behind the pond and along the central path towards the conservatory, which is situated on the Edge Lane boundary. The bottom image is the same view but in the winter, annotated with 'Compliments of the Season'.

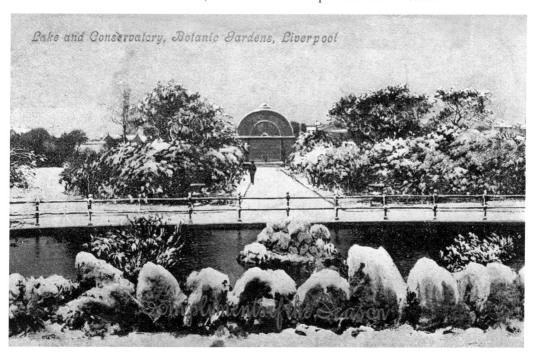

Lake and Conservatory, Botanic Gardens, Liverpool

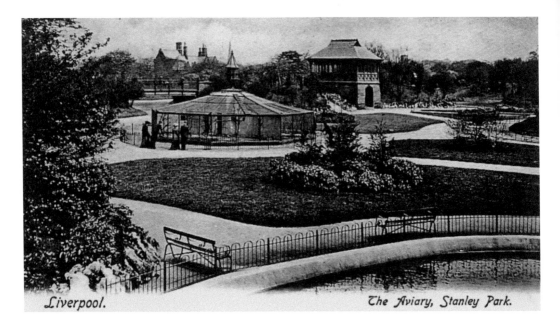

Liverpool. *The Aviary, Stanley Park.*

Stanley Park

Stanley Park was designed by Edward Kemp in 1867 and was laid out between 1867 and 1870. It was named after Lord Stanley of Preston, a former Lord Mayor of Liverpool. The park falls into three distinct areas: a strongly formal, terraced area; a middle ground composed of soft, informal landscaping set below the terrace; and a picturesque area in the north corner of the park that is formed of a structured series of walks and lakes. The picturesque area was also bedded out and later an aviary, the gift of Alderman J. R. Grant, became a feature of this part of the park. The aviary complemented the dovecotes, but it was later dismantled because of its exposed site.

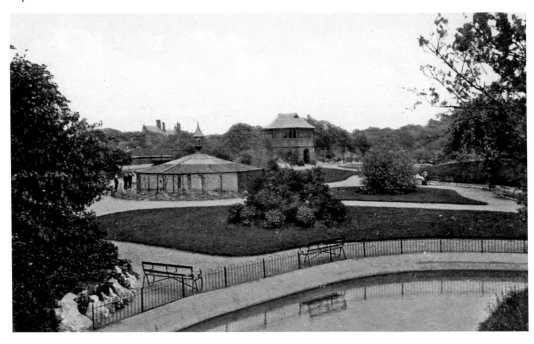

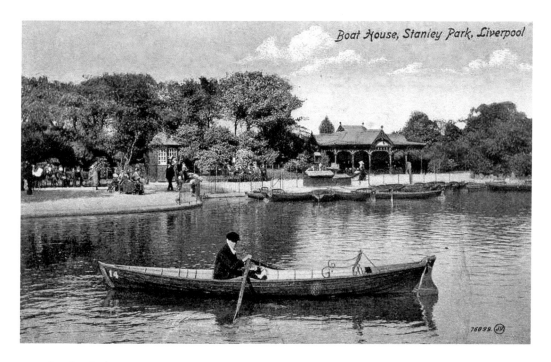

Boat House, Stanley Park, Liverpool

Stanley Park

The large lake is located in the north corner of the park. The lake was divided into four separate sections by planted islands and a series of four cast-iron and stone bridges situated at the east and north-east ends of the lake and a large ornamental, Gothic-style stone bridge towards the western end. Located on the northern shore of the eastern end of the lake was a wooden Gothic Revival-style boathouse. The fourth and smallest section of the lake, set to the north-east of the boathouse, was drained and turned into a landscaped area in the early twentieth century.

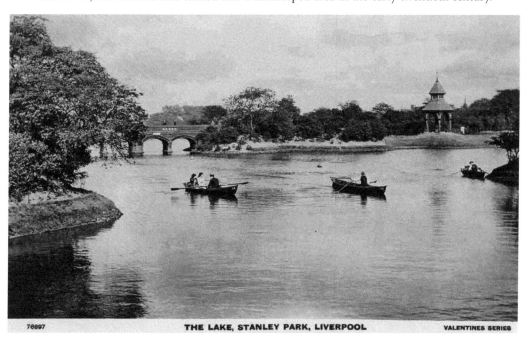

THE LAKE, STANLEY PARK, LIVERPOOL VALENTINES SERIES

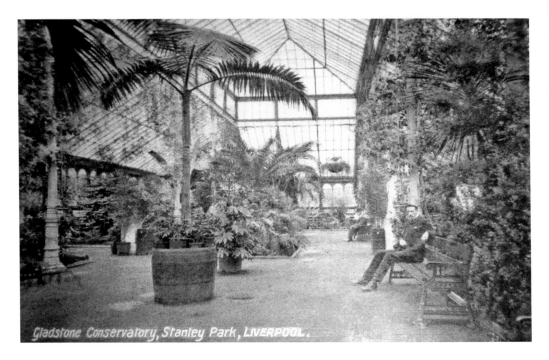

Gladstone Conservatory, Stanley Park, LIVERPOOL.

Stanley Park

In the south-western corner of the park is a large conservatory supplied by Mackenzie and Moncur of Edinburgh in 1899, the gift of the city elder, Henry Yates Thompson. The conservatory suffered bomb damage during the Second World War and did not reopen until 15 September 1958. Alongside the conservatory, a 300-yard terrace provides panoramic views of the area. The terrace is not only a source of fine views but also has shelters, flower beds and three fountains at intervals along its length.

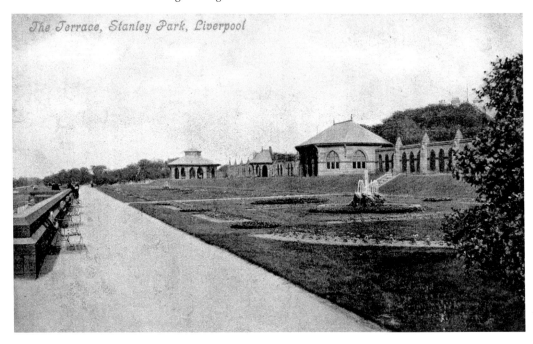

The Terrace, Stanley Park, Liverpool

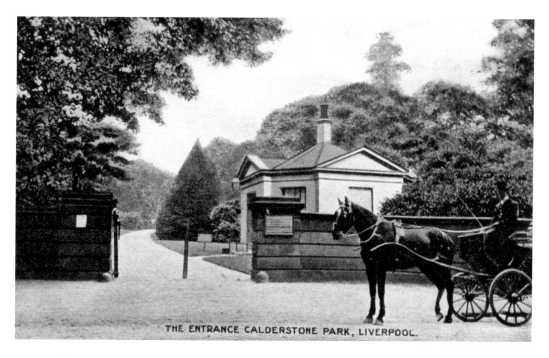

THE ENTRANCE CALDERSTONE PARK, LIVERPOOL.

Calderstones Park

In 1902, the McIver family bequeathed the estate to Liverpool Corporation, who transformed it into a public park. They soon acquired the adjoining estate of Harthill and established the current 126-acre park. The park is named after the Calder Stones, which were dug up on the estate and are Neolithic sandstone boulders that remained from a dolmen. The image above shows the lodge and gate on Hart Hill Road. The main entrance is on Calderstones Road and the track from there to the mansion is shown on the image below.

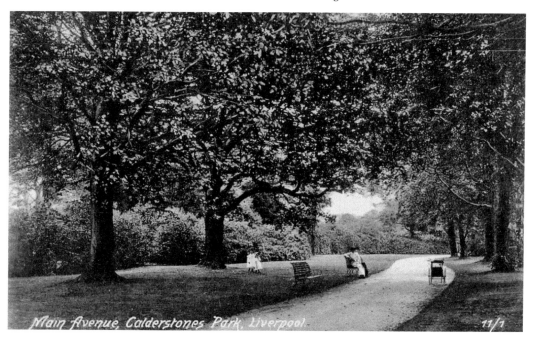

Main Avenue, Calderstones Park, Liverpool. 11/1

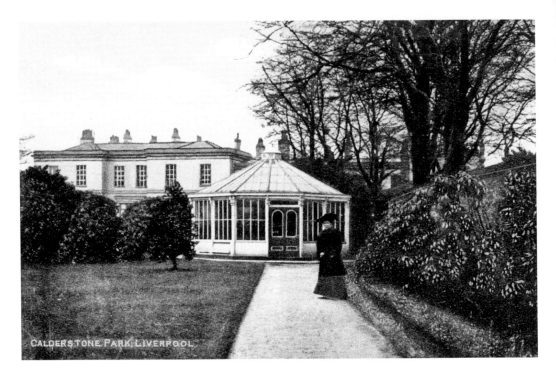

CALDERSTONE PARK, LIVERPOOL.

Calderstones Park

The mansion house was built in 1828 by Joseph Need Walker to replace the original farmhouse, known as the Old House. He also placed six of the Calder Stones at the entrance to the estate as a feature. These were later removed and stored in the Hart Hill conservatory, which unfortunately accelerated their deterioration due to the rapid changes in temperature and humidity. An earlier conservatory near to the Mansion House, shown on the images, was later demolished.

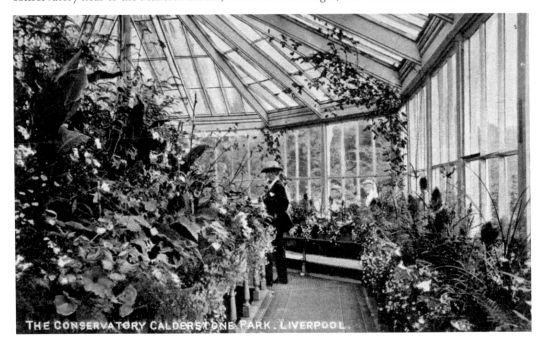

THE CONSERVATORY CALDERSTONE PARK. LIVERPOOL.

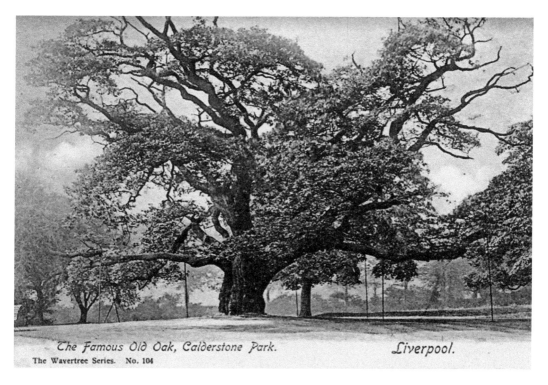

The Famous Old Oak, Calderstone Park. Liverpool.
The Wavertree Series. No. 104

Calderstones Park

One of the park's most ancient features, estimated at 1,000 years old, is an oak tree. According to legend the ancient local hundred court sat beneath its branches. The dilapidated state of the tree is said to be due to the explosion of the gunpowder ship *Lottie Sleigh* over 3 miles away on the River Mersey in 1864. It is dependent upon a number of props that hold it up.

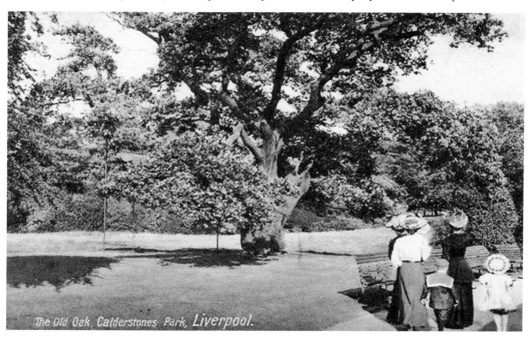

The Old Oak, Calderstones Park, Liverpool.

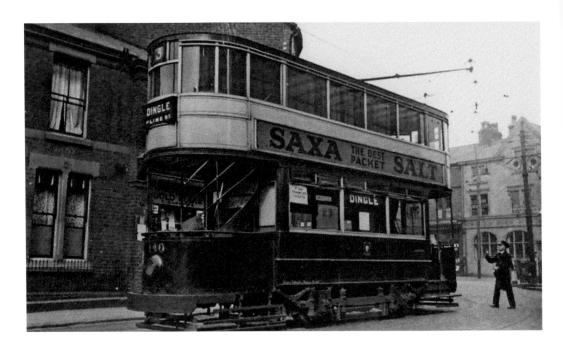

Trams in Liverpool

In 1868, the Liverpool Tramway Company obtained permission to construct an inner circle line and lines to Walton and Dingle. Services started at 8 a.m. on 1 November 1869. By the end of 1875 the network of lines was nearly 61 miles long. At one time services were provided by a stable of 2,894 horses and 207 tramcars. In 1897, Liverpool Corporation took over the routes and the services were continued by Liverpool Corporation Tramways. By 1902 most of the system had been electrified. The advent of buses and private cars led to the demise of the tram system and it was closed down in 1957. The above image shows a Dingle-bound tram, service 3, in Barlow Lane and the one below of services 4 and 5 to Whitechapel and Church Street.

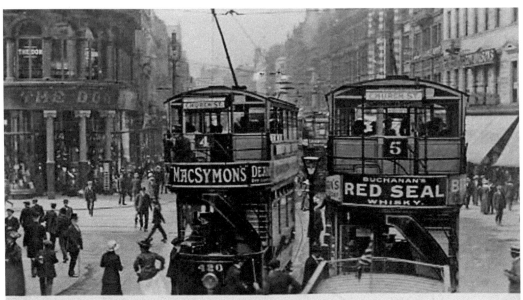

S 13263. WHITECHAPEL AND CHURCH STREET, LIVERPOOL.

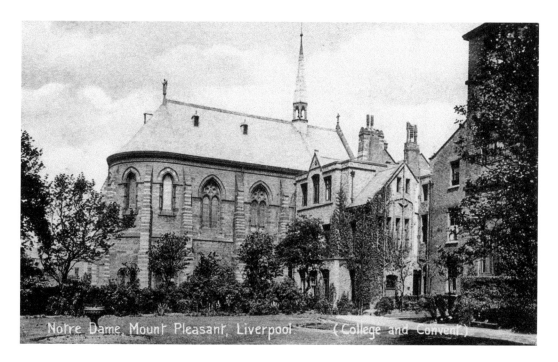

Notre Dame, Mount Pleasant, Liverpool (College and Convent.)

Notre Dame, Mount Pleasant

The Sisters of Notre Dame de Namur was founded in 1805 in France and Belgium for the education of the poor, and it taught nuns to teach in and run schools. Notre Dame started training lay women as teachers from 1856 at a house in Mount Pleasant, but after just a few months it was necessary to provide additional accommodation. Plans were drawn up by the architect Charles Hansom and the new house was built to accommodate sixty students. The house was finished in February 1857 when around thirty-six students entered as pupils.

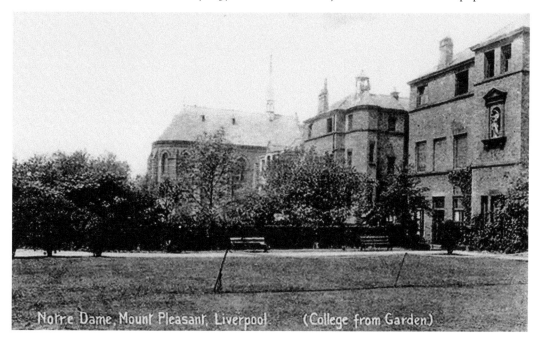

Notre Dame, Mount Pleasant, Liverpool (College from Garden)

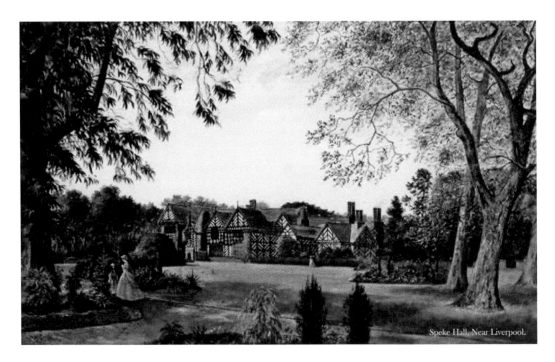

Speke Hall, Near Liverpool.

Speke Hall

Construction of the current building began under Sir William Norris in 1530. The Great Hall was the first part of the house to be built in 1530. The Great Parlour wing was added in 1531. Around this time the North Bay was also added to the house. Between 1540 and 1570 the south wing was altered and extended. The west wing was added between 1546 and 1547. The last significant change to the building was in 1598 when the north range was added by Edward Norris. Since then, there have only been minor changes to the hall and gardens.

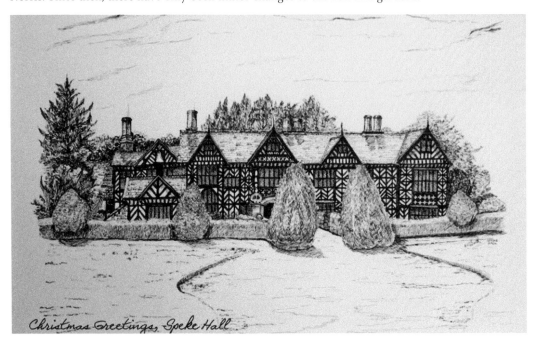

Christmas Greetings, Speke Hall

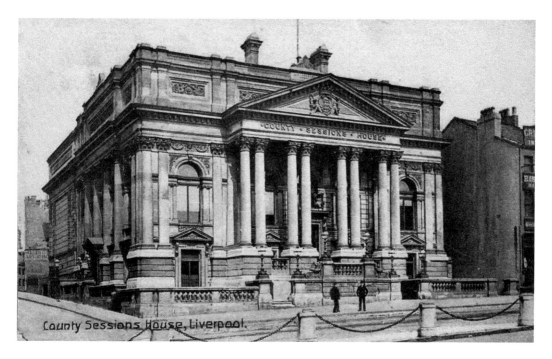

County Sessions House, Liverpool.

County Sessions House, Kirkdale

The need for a new prison had been satisfied in 1819 when the County House of Correction was built in the northern part of the township. A sessions house, seen here, was also built nearby to house the courts, which dispatched criminals to the gaol. The gaol and sessions house were imposing buildings, large in scale and of impressive architectural quality, and at first they stood in glorious isolation surrounded by fields. Both have been demolished, but Sessions Road is a reminder of their former presence.

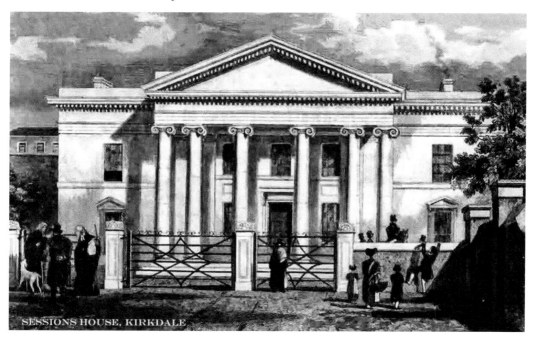

SESSIONS HOUSE, KIRKDALE

SOURCES

Many sources of information have been used in compiling this book, but in particular I would like to acknowledge the following as being very useful:

Historic UK – www.historic-uk.com
Local History – www.localhistories.org
National Library of Scotland historic maps
Wikipedia – www.wikipedia.org

ABOUT THE AUTHOR

Alan Spree BSc, CEng, MICE, MCIHT, was born in Nottingham in 1944 and was educated at Glaisdale Bilateral School in Bilborough. He moved to Portsmouth with family in 1959 and completed his secondary education at Eastney Modern School. He took an apprenticeship as a bricklayer in Portsmouth Dockyard and as part of that he received further education at Highbury Technical College. He then gained a degree in civil engineering at Portsmouth University before becoming a professionally qualified civil engineer. Alan worked with the Department of Environment at Portsmouth, Reading, London and Germany until voluntary retirement in 1998. He then worked for Berkshire County Council and Preston City Council before retirement to Spain in 2006.